Breaking the Rules of
Watercolour

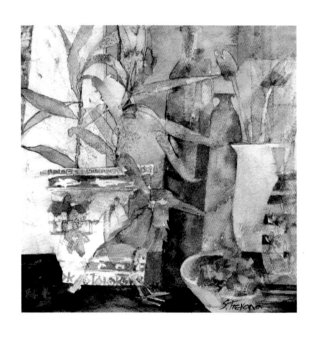

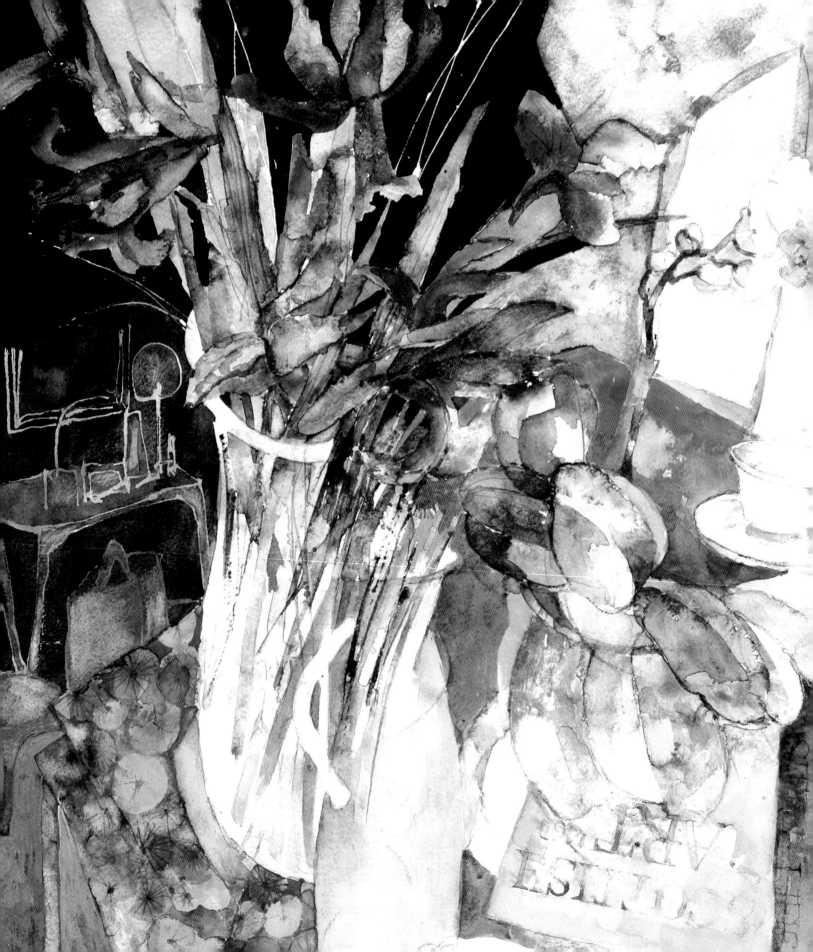

Breaking the Rules of
Watercolour

Shirley Trevena

BATSFORD

First published in the United Kingdom in 2012 by
Batsford
10 Southcombe Street
London W14 0RA
An imprint of Anova Books Company Ltd

ISBN: 9781906388836

A CIP catalogue record for this book is available
from the British Library.

10 9 8 7 6 5 4 3 2 1

Repro by Mission Productions Ltd, Hong Kong
Printed by 1010 Printing Ltd, China

Commissioning Editor: Cathy Gosling
Copy Editor: Diana Vowles
Designer: Kathy Gammon

This book can be ordered direct from the publisher at the website:
www.anovabooks.com, or try your local bookshop.

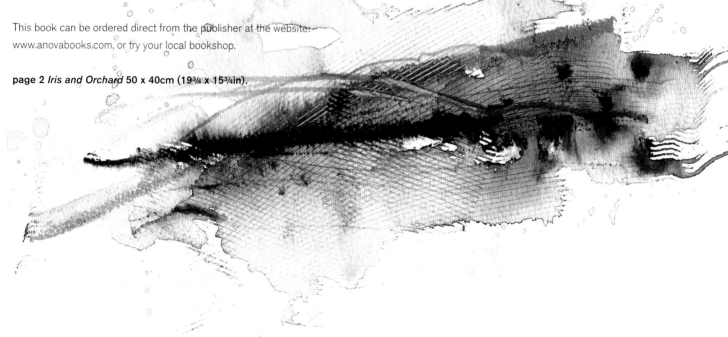

page 2 *Iris and Orchard* 50 x 40cm (19¾ x 15¾in).

Contents

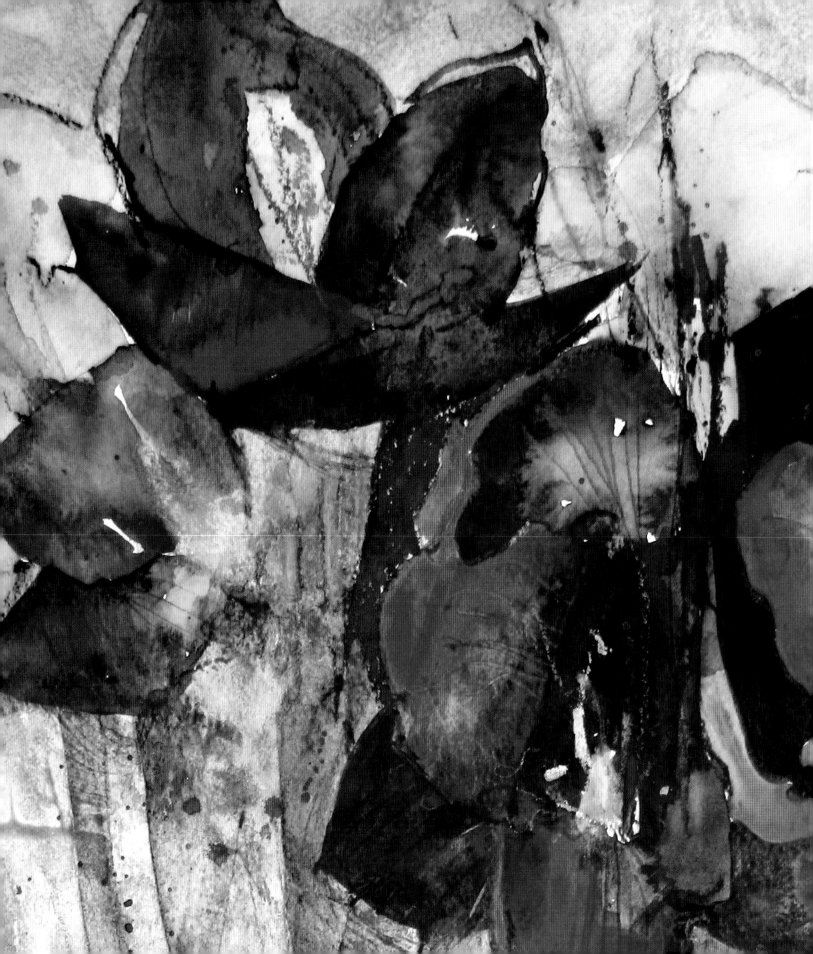

Introduction

When we first set about learning to paint, we are given long-established rules that will help us to create successful pictures. However, as an artist's confidence grows, so does the desire to push the boundaries and to set out on an individual path on which creativity and originality can flourish. But though we have seen many changes over the years in the use of oil paint, sculpture and ceramics and more recently the exciting work being done in embroidery and even knitting, I do feel that watercolour still hasn't quite been accepted as a medium you can take liberties with and push on to its full potential.

'When I am finished painting, I paint again for relaxation.'
Pablo Picasso

Tradition or rule breaking?

What are the so-called rules of watercolour painting and, more to the point, why are they still floating around in the 21st century, continuing to be a big influence on watercolourists?

The traditional delicate watercolour landscape has a strong Britishness about it; we have been famous for using a limited palette to produce scenes of pastoral beauty. Queen Victoria, who was a great fan of this medium, produced many studies of English and Scottish scenery. But I would have loved to have had Her Majesty in my class so that I could have given her permission to let rip with her colours, suggesting she tried painting some blue trees with a touch of pink.

So when I think about these rules of restraint and delicacy, I have to ask myself whether I feel I should be faithful to the purity of using watercolours in the traditional way or strike out and be less inhibited, even dare to use black or paint straight from the tube. I think by looking at my choice of paintings in this book you can see which route I have taken.

Left: Detail from *Pink Pot of Amaryllis.*

About the book

I have always tried to break the rules of watercolour painting. The traditional path of soft colours and a limited palette was never for me.

Over the years I have developed a method of painting that appears to be loose, the paint put down in a casual way. In fact I work very slowly, without any preliminary underdrawing, building up the surfaces and concocting muddled perspective and disjointed picture planes. Unlike the traditional working method of quickly putting down colour, it sometimes takes me up to four weeks to complete a smallish picture and for this I have had to learn patience while the paint dries, patience when choices have to be made and even more patience when it comes to putting my paintbrush down and waiting until morning to get a fresh look at the work.

In this book I analyse 10 of my paintings in depth, taking the reader through the whole process of their construction from my first thoughts about what inspired me to the techniques used in my deciding on major changes and finishing touches. I have chosen each of these paintings to illustrate my own path of rule-breaking, from being more open-minded about stepping away from my usual colour range to using bigger paper and more paint.

As a working artist I am fully aware of how difficult it can be to step out of your comfort zone and try to break a few of your own rules of painting. I often find myself turning to tried and tested techniques for my work, sometimes for comfort in doing what I know best or for the pressing need to produce paintings for a deadline. At times like that, to experiment with colour and marks becomes a luxury. But I have learnt far more from making a conscious decision to break away from what I know best to discover new and exciting ways to make marks on paper.

So here are a few paintings created when I have done just that. Some of them may have been painted after several experiments and lots of mistakes, but they have all kept my interest in doing watercolour paintings that are fresh and alive.

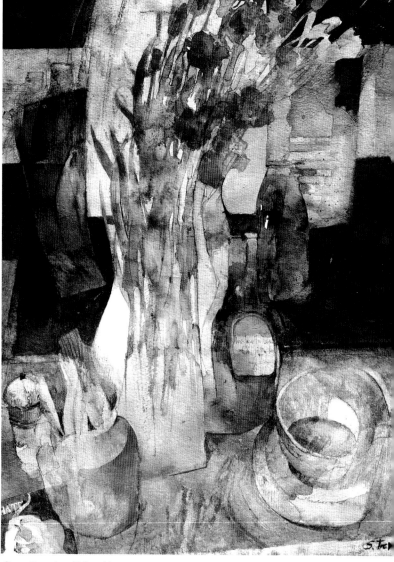

Carnations in a Yellow Vase
50 x 36cm (19¾ x 14¼in)
Here I have broken away from perspective rules by using objects and space in a more random way.

The traditional path of soft colours and a limited palette was never for me.

Right: *Irises by the Rock*
70 x 56cm (27½ x 22in)
Mixing pencil and paint produced mysterious shapes on the unpainted white paper.

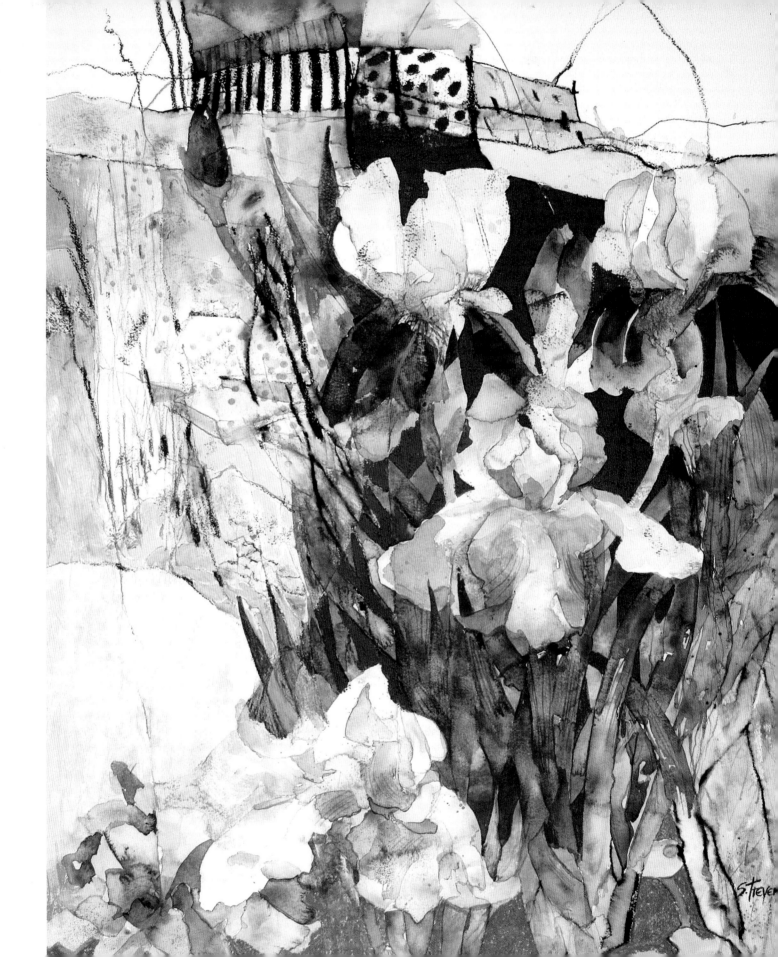

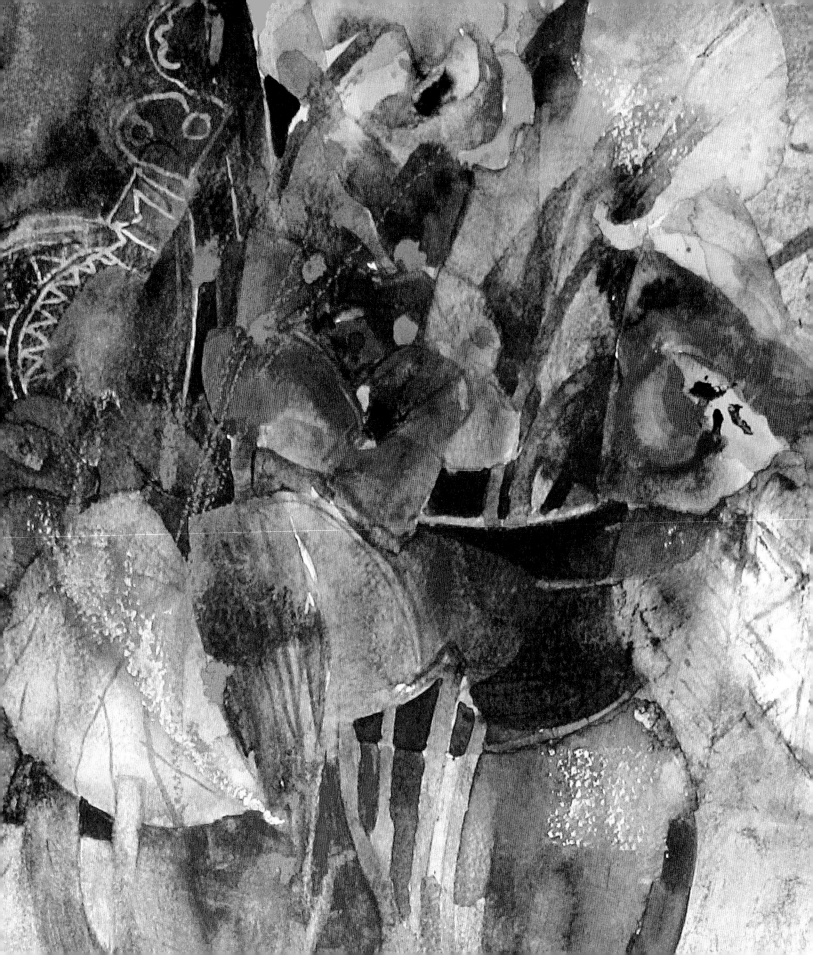

Starting with paint, not pencil
Red Flowers and Figs at Rauffet

I like to be in a situation in which I have to form a mental picture of my ultimate painting without depending on a detailed drawing. With pencil lines on the paper in front of me, I'm always tempted to fill in the shapes with colour. I prefer to put paint to paper without a lifeline, as I never know what exciting things might happen.

Painting without making a drawing first also leaves me freer to change my concept in midstream. This could mean changing either the composition or the subject matter.

Starting to paint in France

In 2007–2008 my husband and I had the chance to experience living at Rauffet, in the Dordogne, for 15 months. It proved to be not just a wonderful adventure, but a time of great creativity. The mix of being surrounded by beautiful countryside, with a house full of exciting new objects and, most of all, no distractions, gave me perfect working conditions – that is, when I wasn't struggling with my French verbs in the hairdresser's or playing with the little cats that appeared on my doorstep!

Red Flowers and Figs at Rauffet was the first painting I attempted at the beginning of our stay in France and after much blood, sweat and tears I completed it.

'Painting is easy when you don't know how, but very difficult when you do.'
Edgar Degas

Left: Detail from the finished painting (see page 19).

It had taken us a long time to plan our trip and get settled into our beautiful house, which meant that it had been at least four months since I had been able to do any serious painting. Taking a long break like that always leaves me struggling to get started again, feeling jumpy that I haven't been near a paintbrush for some time, but desperate to get going.

We had rented a house full of objects that the owner had lovingly collected over the years – sculpture, pottery, fabrics and rugs, all ready to give me fresh ideas for my still-life paintings. When the day came that I felt I really could not put off painting any longer, I prowled around the house sketching and photographing pieces, unpacked a few objects I had taken with me and prepared to work on the large wooden kitchen table.

Sometimes when I see an earlier painting of mine I look at it and wonder how on earth I did it.

The first day of work was a day of trying to remember how I made different marks – I really do have to remind myself after a long break. Sometimes when I see an earlier painting of mine I look at it and wonder how on earth I did it, almost as if someone else were responsible for it. In a situation such as this I usually do a page of mark-making; I get out all my materials and remind myself of the techniques that I have learnt over the years.

This painting is a good example of how I sometimes use different forms of reference – a combination of my own photographs and objects and patterns from around the house rather than a complete still-life set-up on the table in front of me. It is a sort of artistic juggling act.

Finding shapes

Where we were living entailed a long drive just to buy milk or bread and finding an interesting flower shop proved very difficult, so I used for reference some tulips that I had photographed in England. I particularly liked the variety in this photograph (right) which has a triangular-shaped flower head. In the finished painting these flowers have had their shapes tweaked and added to so much they could be any species, but I like that. It provides a puzzle for the viewer, who is not quite sure what they are looking at.

Triangular-shaped tulips photographed in my garden.

A plate of figs waiting to be painted.

A jug and pencil holder chosen for the set-up.

The jug was chosen for its colour, bringing more red into the design, and the dark collar, which exaggerated the redness of the flowers. The only other definite choice of object was a plate of figs that was sitting on our kitchen table begging to be painted – the pink-red flesh would work well to bring the reds down to the bottom of the composition.

I then had to decide on what other colours I would be using. With the reds and greens already chosen, I cut out pieces of coloured paper from magazines to give me ideas of possible combinations. This is a quick and easy way to make choices, as you don't even have to mix up the paint.

I had brought the pencil holder and the little duck (*left*) from home, but for the background I used information I had sketched in the French living room, including the strong pattern on the black-and-white rug and some metal sculptures and musical instruments. I then had to bring together all the various pieces of information to form an interesting still life.

My preliminary choice of colours using paper cut-outs.

A pencil sketch of a wooden duck.

Detail of a black-and-white carpet design.

My basic thumbnail sketch, giving me a general overall idea of the composition. The painting more or less reflects this; just a few things were changed.

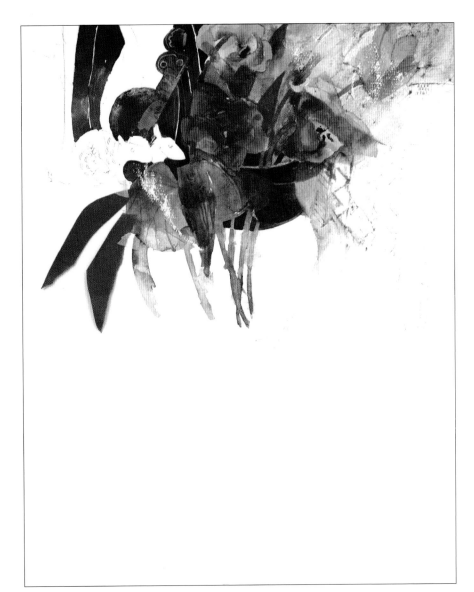

Stage 1
I began by working
outwards from the
vibrant red flowers.

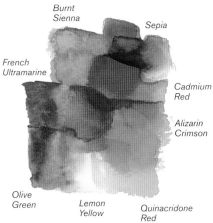

Burnt
Sienna

Sepia

French
Ultramarine

Cadmium
Red

Alizarin
Crimson

Olive
Green

Lemon
Yellow

Quinacridone
Red

Colours used in *Red
Flowers and Figs at Rauffet.*

Stage 1

This was the first stage of the painting. It took me a week to get this far. I was dipping in and out of it every day, nervous that I was going to put down the paint too quickly and ruin it.

I kept a diary about its progress and this is what I wrote after a week: 'It's not a bad start. I do like the colours at this early stage but it is hard not to go off the rails into multicolours like I usually do. It is going so slowly because after four months it feels like starting all over again. I know that will pass eventually.'

On the top left-hand side of my initial painting you can see the outlines of an African stringed instrument and two little metal rabbits which I had discovered in the French house.

The two leaves on the left are cut-out bits of green paper. If I have any doubts as to positioning areas of colour I always use this method of loosely attaching pieces of coloured paper and moving them around until I find the best balance for the composition. It is a lot easier to remove a misplaced piece of paper than to try to take out a dark patch of watercolour.

Stage 2

The top left-hand side is now completed, making a dark triangle, which has partially concealed the shape of the animals and the instrument, pushing them right back. I was sure I wanted to add the pencil holder with its rhythmic pattern so I went ahead and painted that, including an assortment of pens and pencils. Below this I lightly pencilled in the outline of the wooden duck.

Stage 2
The top section is almost completed.

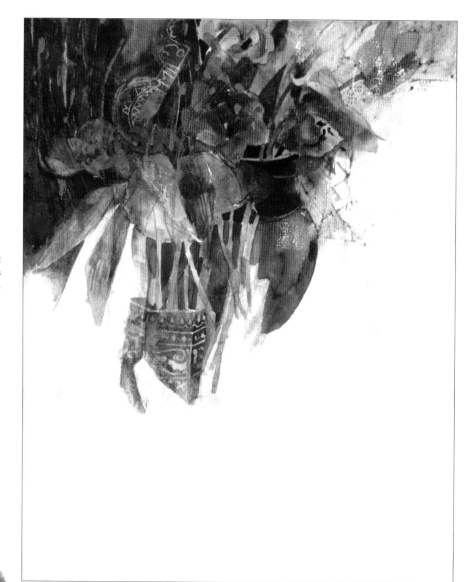

The shock of adding blue dots to red.

I looked through an old magazine for a possible alternative colour to paint the duck, because I felt its silvery black was just too heavy for an object in the lower half of the composition. I cut out a small piece of pale grey paper and dropped it on the painting but it landed on its other side, which was a vibrant cobalt blue. The effect was electric and I just had to add a small amount to react against the vermilion flowers. The paint was densely applied in the area where I wanted to add the blue, so I decided on using an oil crayon to go over the paint to apply my blue dots. Quite shocking against the red, they were hard to look at, just like everything in the brilliant midday sun in the Dordogne.

In my thumbnail sketch I had a small pot of flowers to the left of the pencil holder and to make sure that decision was right I cut out the shape of some pink paper flowers and placed it on the painting. Realizing it didn't balance the composition, I didn't add it in. One of the helpful things about not drawing out the composition on the watercolour paper is that you are not tempted to just fill in with colour – you can change your mind and make a better decision.

Work in progress, including paper cut-outs.

Stage 3

I extended the small glass bottles containing brushes and twigs in the centre of the painting, which gave me some interesting negative spaces between the duck and the plate.

I had to blur out the pencil shapes to make them less important, add information about the right-hand side of the table and add a chair. I finally gained the courage to tackle the rounded shape of the plate, painting just a small slice of it a pink blush, leaving one green fig to take the eye to the right for balance.

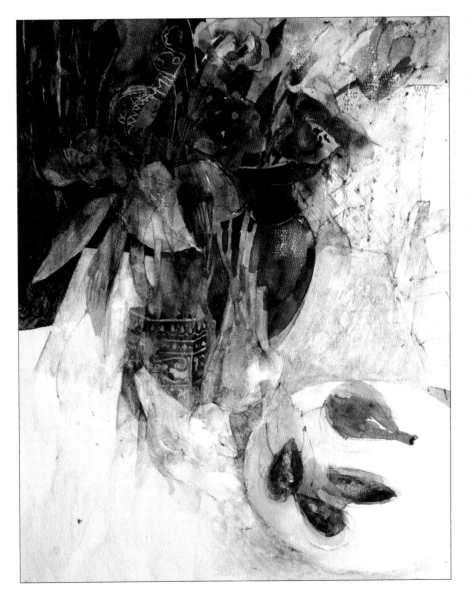

Stage 3
The lower section
is painted in.

Final stage

I wasn't happy with my choice of pink for the plate. It didn't have the strength to carry the eye down the picture and made the red flash of the figs seem isolated. I loved the cobalt blue dots but that colour would have jumped off the page if I had used it all over the plate so I went for a much warmer blue – in fact the blue that I had originally sourced from my magazine. I did make the blue dots dance down a little further to join up with the glass bottles, creating a flow of blue from the top to the bottom of the painting. The left edge of the table I turned into a curve, which made the whole table rise up and flatten out the composition. The duck's head and pink beak were now more defined, but I didn't want to paint him completely – he had to be kept a little secret.

Detail of the partially hidden wooden duck.

The final thing was to put in my pencil marks. I know that it is usual to put these in first as guidelines but I do it the other way round, finishing off my painting with lines suggesting mysterious objects or extensions of existing objects and their shadows.

Red Flowers and Figs at Rauffet was a marathon; it took me four weeks to finish. After all, it was the first painting that I completed after a long break so it took a lot of planning before I even got out my paints and even more courage to make the first marks on the white paper.

Pencil marks added at the end of the painting.

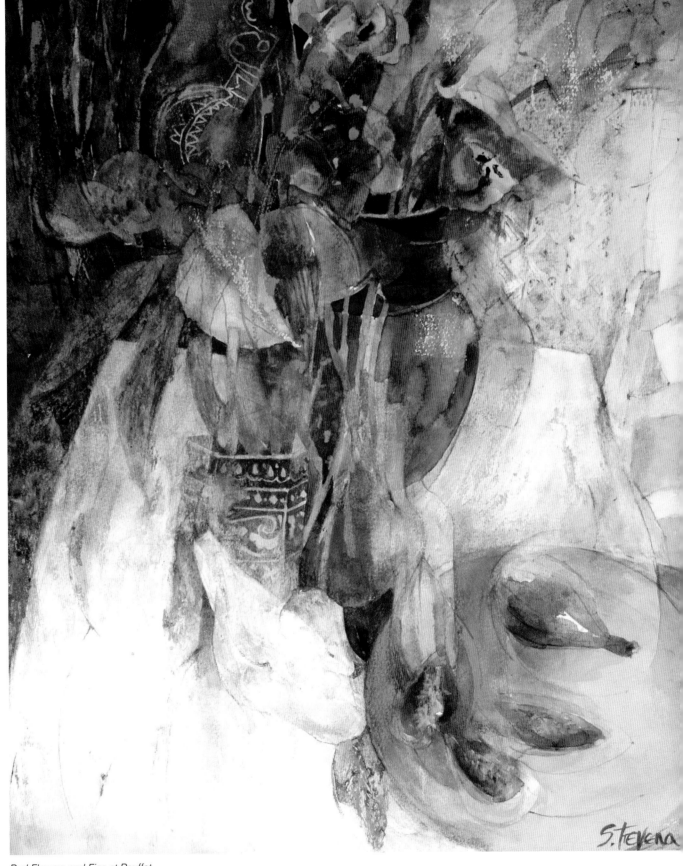

Red Flowers and Figs at Rauffet
48.5 x 38cm (19¼ x15in)

More paint – bigger paper

Tournesols

Just looking at a single sunflower gave me a huge amount of information to use in this painting, which I suppose you could call a portrait of a flower. In trying to catch the essence of these giant flowers – their size, their strength and their complex form – I decided to use a larger piece of paper than is my usual choice. The flowers were going to have to be painted slightly larger than life and after choosing only three freshly cut blooms I would have to make the composition strong and uncluttered.

I had painted these flowers many times before, but never in such a large, bold form. However, these great golden discs, which seem to embody all that is summer, even turning to face the sun as it passes overhead (hence the French name, *tournesol*), demanded to be painted in a grand style with big colours and big shapes on big paper.

The paper had to be firm enough to take all the water and paint that I was going to throw at it.

Left: Detail from the finished painting (see page 28).

'*Art is the unceasing effort to compete with the beauty of flowers and never succeeding.*'
Marc Chagall

A field of sunflowers

Sunflowers en masse appear to be a vast swathe of saffron yellow and when they are at their best in full bloom it is a breathtaking sight. However, their individual colours span a whole range of browns and yellows from deep bronze to citrus yellow, all topped off by their wonderful honeycomb-like dark chocolate centres. To support these weighty flowers the stalks are thick and tough, but if they have been cut and left standing in water for some time the stalks can turn a delicate translucent green. Their huge leaves also change when cut, turning quickly into wilted muddy rags.

A field of these giant platter-like flowers attracts butterflies, bees and artists, and while I was living in France I took great pleasure in standing amid their serried golden ranks and joining them in turning to face the sun.

Over the years I have painted these flowers several times, but I rarely add them to a set-up for a still-life painting. Perhaps their rigidity and strong personality require them to stand alone, uncluttered by small objects.

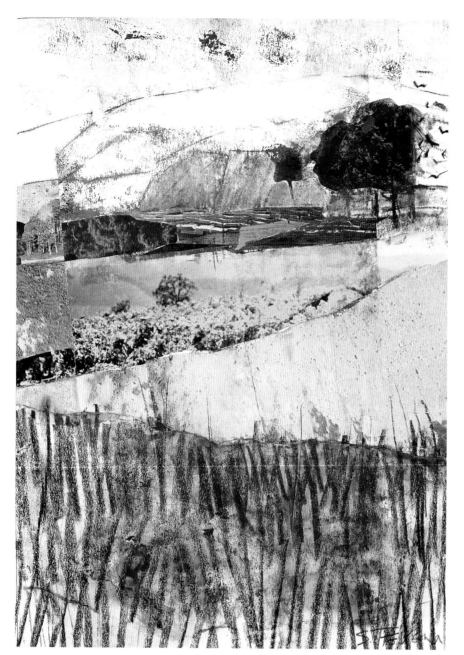

Yellow Field
40 x 28cm (15¾ x 11in)
This field of sunflowers was executed as a monoprint with collage, watercolour and pencil.

A field of these giant platter-like flowers attracts butterflies, bees and artists.

Setting up the painting

My three sunflowers were in full bloom when I collected them, with crisp petals and shiny green leaves ready for me to start the painting. I placed them in a simple glass vase in front of the light source – a small window – giving me good verticals and a light/dark source to work with.

Trying to find a good composition for the sunflowers.

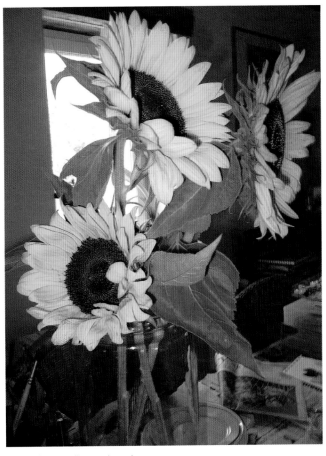

Three giant sunflowers in a glass vase.

When using large, heavy paper and lots of paint and water I paint standing up.

The power of the sunflower image

To do a watercolour painting of these large, heavy flowers I felt the need to use strong paper and a lot of paint. The NOT surface paper that I wanted to use needed to be 638gsm (300lb). Its size, 76 x 57cm (30 x 22.5in), meant that it would be difficult to stretch, so it had to be firm enough to take all the water and paint that I was going to throw at it. I wanted the finished look to be solid and textural rather than the usual delicate layers of watercolour paint.

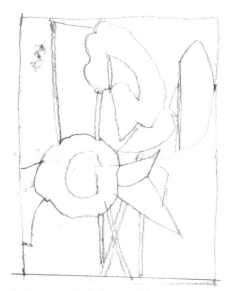

This was my basic thumbnail sketch, helping me to position the three large shapes and to find a good composition.

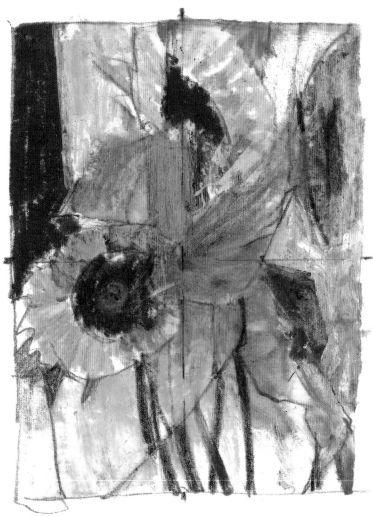

This little final sketch would prove very valuable to me in my choice of colours. When it came to the final decision about what would give me that feeling of bright sunshine and hot flowers, it was all there in this tiny picture.

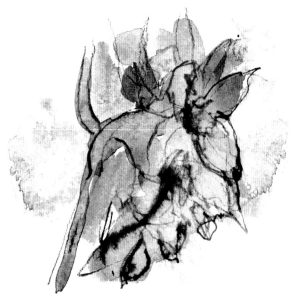

My drawing of sunflowers.

Comparing the early sketch to the final image

I used oil pastel and pencil to make this final colour sketch before I dared to put down any paint. Comparing the small drawing to the finished painting (see page 28), I find it surprising how little was changed. However, the lower left-hand quarter of the picture has become much paler and the very dark shadow on the left has been reduced. The lower sunflower has lost colour from both its petals and most importantly its dark centre, which is now partially a light bluish-pink wash. I felt that the weight of the painting should be more in the upper half of the composition to make the flowers appear to be stretching up to the light. The stalks have been changed to appear more robust to carry the weight of the flowers. They are now darker and the paint is more dense.

Transferring a small sketch into a large format

I liked the small original sketch with its broad strokes, but capturing these solid gestures on a larger scale would prove difficult. In the past I have been disappointed in trying to transfer a small picture into a larger format; the freshness and looseness are hard to sustain when you scale the painting up. To obtain the same look of solid colour this was definitely a case in which oils or acrylics would have been perfect, but I wanted to see if I could use watercolour and some gouache to get that textured look.

The problem with a big piece of paper and only three flowers is that you are left with a lot of negative space. I decided that to keep this flower painting strong, the spaces needed to be kept simple, with just the turquoise areas singing out around these fierce shapes.

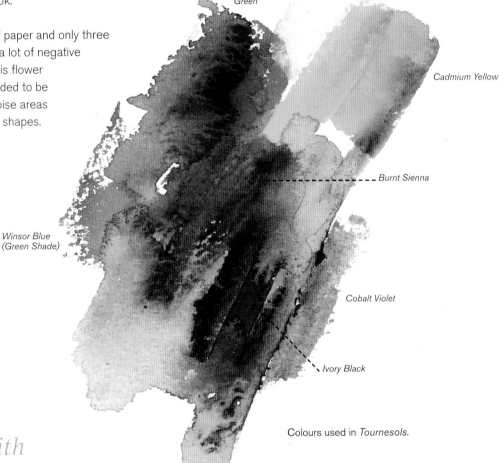

Perylene Green

Cadmium Yellow

- - - *Burnt Sienna*

Winsor Blue (Green Shade)

Cobalt Violet

Ivory Black

Colours used in *Tournesols*.

The problem with a big piece of paper and only three flowers is that you are left with a lot of negative space.

Techniques used

I started with the central flower at the top of the composition, squeezing the paint from the tubes on to the paper, smudging it with my fingers and spreading it with a cut-up credit card. I tried not to paint the petals carefully as I didn't want to capture each little lozenge shape.

Above, detail of *Tournesols*.

Painting gouache over watercolour and scraping in marks gives interesting texture.

I stayed with my original choice of a block of turquoise under the first flower then added a finger of cadmium red beside it to set up a vibration of complementary opposites. This area with the brown-red petals of the lower flower would prove to be the heart of the painting where all the heat is contained, rather like golden sunshine and swimming-pool blue, the perfect summer combination.

The turquoise was painted over the whole of the upper half of the picture. Then, using white gouache straight from the tube with no water, I scraped over the blue with part of a credit card and a bristle brush, partially covering it but letting it still shimmer through, using my water-based paints as if they were oils or acrylics. And so I worked through the shapes from top to bottom, only adding paint next to existing paint rather like doing a jigsaw. Each leaf was partially painted then left to dry completely before I added more paint for the next one; this made sure the leaves kept their individual shapes.

When I got to the last sunflower I stopped after painting only half of it. This is what I usually do to give myself time to think about whether I really need to describe the whole of a flower, or if I have already given enough information about what the flowers are. This proved to be the right thing to do, because the pale yellow has let in the sunshine and become quite bright compared to the colour of the other sunflowers.

The only clues the viewer gets about where the vase of flowers was placed are the solid dark shadow on the left-hand side suggesting the edge of a wall and the diagonal line under the flowers, which is a perspective view of the edge of the windowsill.

This same diagonal line can be read as the waterline in the vase, creating a shifting reflection of the stalks.

The legacy of Van Gogh's *Sunflowers*

Vincent Van Gogh's painting *Sunflowers* is a very familiar image, and as it is reproduced not only as prints to hang on the wall but also on other items. From tea towels to shopping bags we see his personal view of these golden flowers on various surfaces. In fact he painted sunflowers many times, capturing his infatuation with the yellow sunlight colours and vigorous shapes but also showing some of them well past their best with fallen petals and then with no petals at all, just the hard-seeded centre.

In *The Last of the Sunflowers* (right) I have shown them as having been in a vase of water for some time, with their stalks bleached to a pale green. Just as Van Gogh was interested in the tortuous shapes they take on when losing their petals, I also wanted to paint the flowers passing through the last stage of their short life.

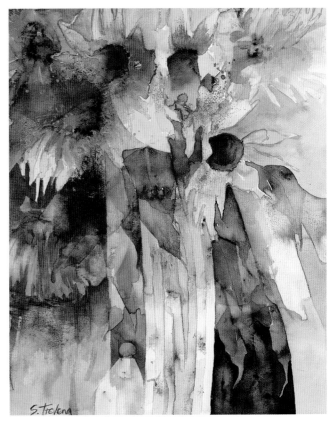

The Last of the Sunflowers
48 x 38cm (18¾ x 15in)

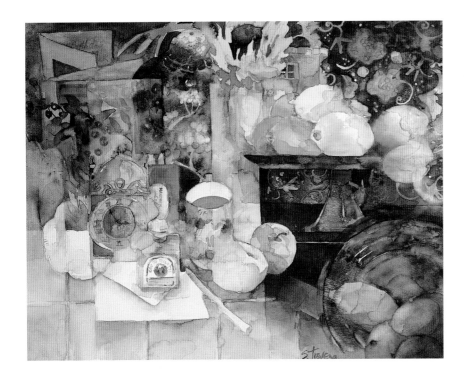

In *Very Yellow Lemons* (left) I have had the courage to add one sunflower to the set-up, but even then it is sliding out of the top of the composition; rather than showing off, it is definitely taking a back seat to the rest of the objects. It must surely realize that it is only there to complete the crescent of yellow across the top right-hand corner of the painting. But if you place your hand over the image of the flower the whole composition does become quite flat, everything sinking to the bottom of the picture in spite of all these objects. The sunflower is in fact quite an important element in this composition.

Very Yellow Lemons
38 x 48cm (15 x 18¾in)

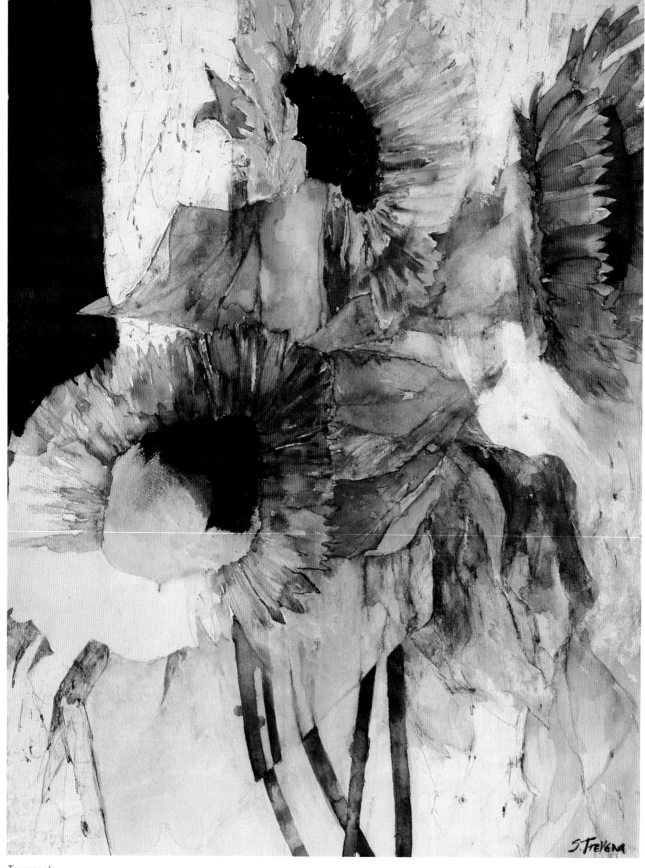

Tournesols
76 x 56cm (30 x 22in)

Sunflowers, Provence
10 x 10cm (4 x 4in)

I made an attempt at thinking like Van Gogh for my choice of colour in this tiny painting.

Scaling up

A change of scale to a large size can be liberating, unlike dealing with these examples of small watercolours, which were easier to control. Thinking of new ways to paint large areas of watercolour makes you experiment to produce different textures.

Sunflowers
10 x 10cm (4 x 4in)

This is the smallest painting I have done that is devoted entirely to sunflowers.

Field of Sunflowers, Tuscany
27 x 35cm
(10½ x 13¾in)

Another field of golden yellow that was just waiting to be painted.

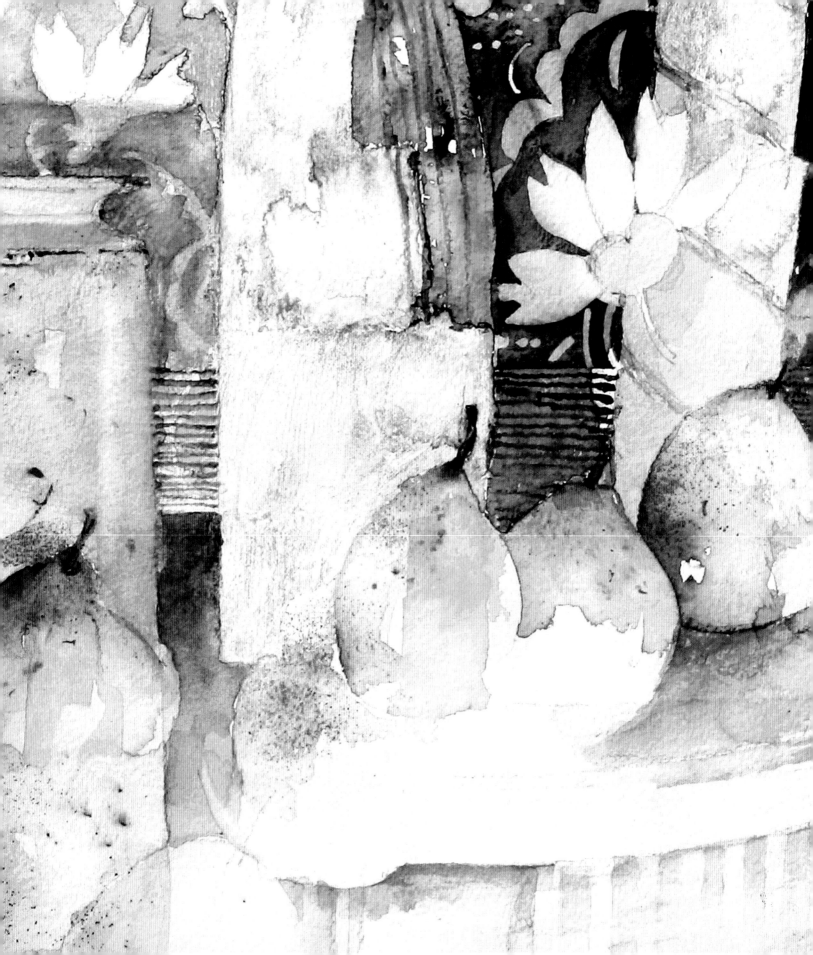

Leaving my options open
Still Life with Chinese Pears

Inspiration for what will be my next painting doesn't come easily; it's not a matter of lying on a sofa in my studio with my eyes closed and suddenly seeing a picture form in front of me. Even when I get the painting started I tend to leave all my options open so that I can change my mind on just about everything throughout the painting process. I never know exactly how the painting will end up – and this includes the question of whether it will be framed or lie hidden in a drawer for a long, long time.

'A painting is never finished,
it simply stops
in interesting places.'
Paul Gardner

Inspirational colour combinations

My paintings always take on a life of their own when I'm about halfway through putting the paint down. More than anything else, combinations of colours get me itching to start a painting and although *Still Life with Chinese Pears* is more neutral in tones than my more colourful compositions, it was still the excitement of the colour combinations of pale yellow pears and delicate pink tulips that was my starting point.

Pink and yellow – my starting point.

Left: Detail from the finished painting (see page 38).

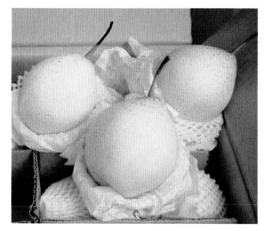

A selection of Chinese pears.

The pears appeared in my greengrocer's display of fruit and vegetables. This shop is always a great source of inspiration for me and I am often to be found browsing through the contents with just as much excitement as if it were a florist or a shoe shop.

The pears had been carefully placed in their tissue-paper nests and lined up in a wicker basket. As I looked at them, my mind went to Naples Yellow with a hint of Burnt Sienna and little stalks painted in dark Sepia. I resisted buying the whole basket, but took home six pears and hoped that they would retain their colour and shape during the time that I needed to paint them.

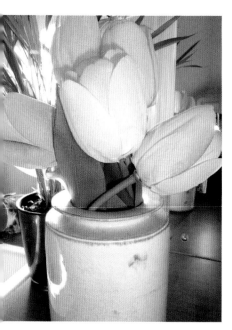

These tulips are silk flowers in just the right pale pink to complement the yellow.

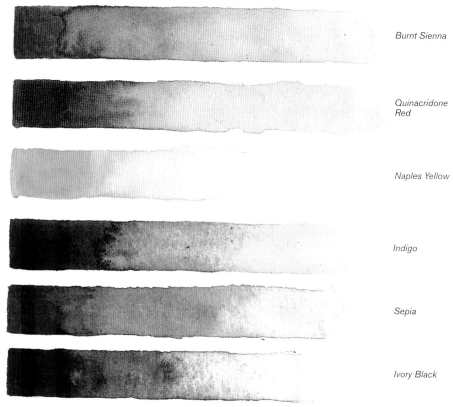

Burnt Sienna

Quinacridone Red

Naples Yellow

Indigo

Sepia

Ivory Black

My colour choices for the painting.

One of my favourite fruit compote dishes, originally chosen for its delicate blue pattern.

A Jane Muir sculpture, *Pea Pod Man.*

Finding the right props

So here was the starting point for my still life. I now needed to hunt through my props to find complementary objects, along with ideas for the background and foreground.

There are three vases in this piece, all in very delicate colours, and when I put the objects together I realized that I wanted to keep this pale, washed-out quality over the whole painting. I delight in using strong, punchy colour combinations and to tone these down I would have to step out of my comfort zone and handle a cool, limited palette – not an easy prospect.

My other objects were a piece of ceramic sculpture by Jane Muir called *Pea Pod Man*, which was chosen to give height to the still life, a flat fruit compote dish and a wooden sculpted rabbit. The whole composition would be held together by the strong black-and-white pattern of a tablecloth that I had bought from a Swedish manufacturer. Although patterned with flowers and stripes, it still retains its cool design, ideal for my limited palette idea. I placed a piece of black card behind the set-up – I wanted to use more neutral colours, go paler and then leave the small areas of black to give the composition a bit of drama.

Preliminary sketch of a wooden rabbit.

The preliminary drawing

After I had decided on objects and the colour scheme, I set up my still life and made a small pencil sketch on a note pad.

I then put tracing paper over the drawing so that I could try out different tones and colours over the composition. I find this a useful way to arrive at my final decisions. I can throw away the tracing paper and I still have my preliminary sketch in its original state.

Although I may do a small preliminary drawing of a set-up, I never transfer that on to my watercolour paper to be my guide. The only thing that I planned to draw carefully on my paper for this painting was the pattern of the tablecloth. I wanted the design to be sharp in one area and to cross in front of some of the objects, possibly the slender white vase, adding to the visual tricks and helping the background to come forward.

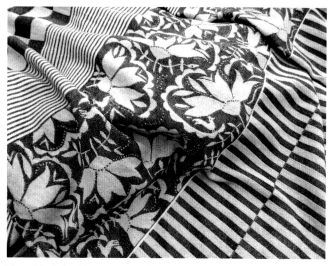

The tablecloth with a wonderful Swedish design.

A big change to the tonal arrangement in the sketch is that I have carefully painted the cloth on the right side and faded out the pattern on the left. Because I never quite paint a whole object my options are left open to paint now or later, and in this case I found the darks only on the right-hand side much more exciting than the idea of the whole design filled in with the same tones. To push this even further, I made the extreme right of the painting really dark and textured.

I made another change from the sketch as I worked down the painting; I altered the perspective of the fruit dish so that the viewer could see into the bowl. This helps to drop the eye smoothly from the top to the bottom of the composition. I also ignored the fussy pattern and gave it a simple blue rim. I only painted half of the dish so that I could make a decision later about how many pears should tumble over its edge.

As a result of changing the viewpoint of the fruit dish and abandoning the idea of a black tabletop, the main thrust of the composition is now around those objects surrounded by the floral pattern rather than the original idea that the viewer's eye would bounce from top to bottom of the painting, taking in the two black areas.

Because I never quite paint a whole object my options are left open to paint now or later.

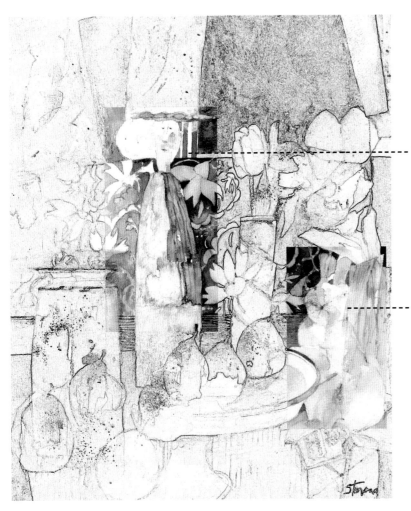

The *Pea Pod Man* sculpture had to have its colour toned down and once again was only partially painted to leave my options open. The face has almost disappeared but the sculpture is important in this composition, adding height to the set-up.

The rabbit is hardly painted at all and has become one of the secret objects that I sometimes put in my work. He consists of soft watersoluble graphite pencil lines which flow into the patterning of the cloth, and his pink ears lead up to the tulips. If you look closely you can just see his nose and eyes.

Don't rush in with the paint

When I was teaching watercolour painting I found that my students felt they should finish their piece in one day, getting the paint down quickly and loading the paper with layers of colours before each one could dry properly. I remember the cries of 'Why have all the colours gone a muddy brown?' The answer is that colours may all mix together if you don't have the patience to sit back and wait.

This is how I discovered that by only half-painting objects or by leaving white spaces I could make decisions later about whether I really needed to paint a whole jug or get rid of all the white paper surrounding a flower. I liked the idea of what I had left out of the picture becoming as interesting as the areas that I had painted.

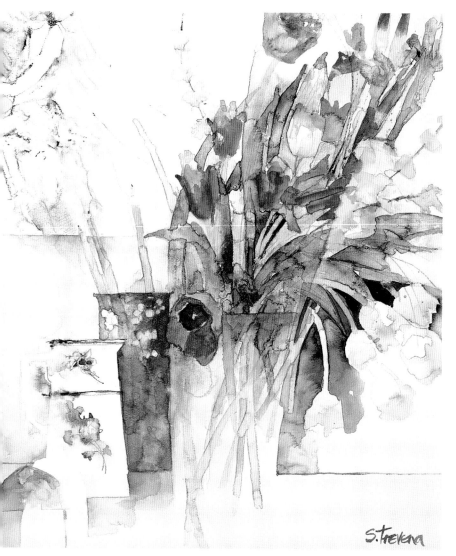

Colours may all mix together if you don't have the patience to sit back and wait.

Fresh Cut Flowers (left) is an early example of my ethos of 'keep it simple'. I haven't painted a vase to contain the flowers – that's up to the viewer to imagine. The pale pink tulips are only suggested and the background is mainly white paper. The whole painting is centred around that one red tulip.

I learnt quite a lot about 'less is more' while painting *Still Life with Chinese Pears*. Completely out of my comfort zone with its paler tones, I was forced to get my dark areas to work hard to pull the painting together. I also found that I only needed to identify my set-up material by suggestion, letting the viewer's imagination work a little harder. By not rushing in with the paint, having more patience and letting the watercolour dry, I felt quite free to change my concept in midstream.

Fresh Cut Flowers
53 x 49 cm (21 x 19¼ in)

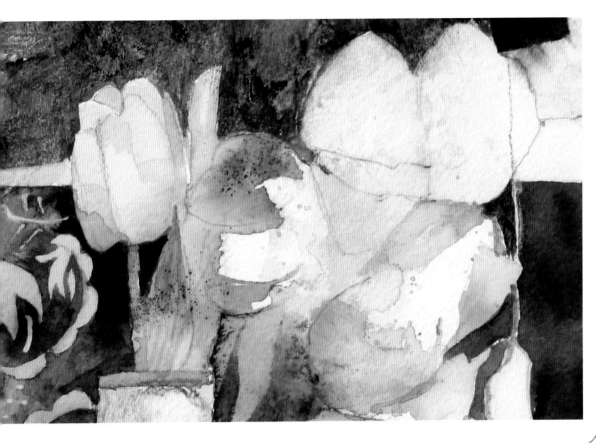

In this actual-size detail of *Still Life with Chinese Pears* you can see how the paint has been only partially applied on the flowers, just in case I needed the white paper showing. In fact the white areas make interesting shapes, which can be read as more flowers or anything you can imagine.

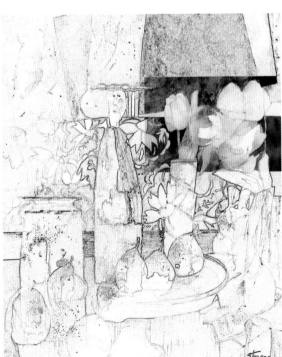

The coloured section of the painting is the detail shown above.

There was a lot of overdrawing at the end of the painting and for this I used a watersoluble graphite pencil and softened the lines with water.

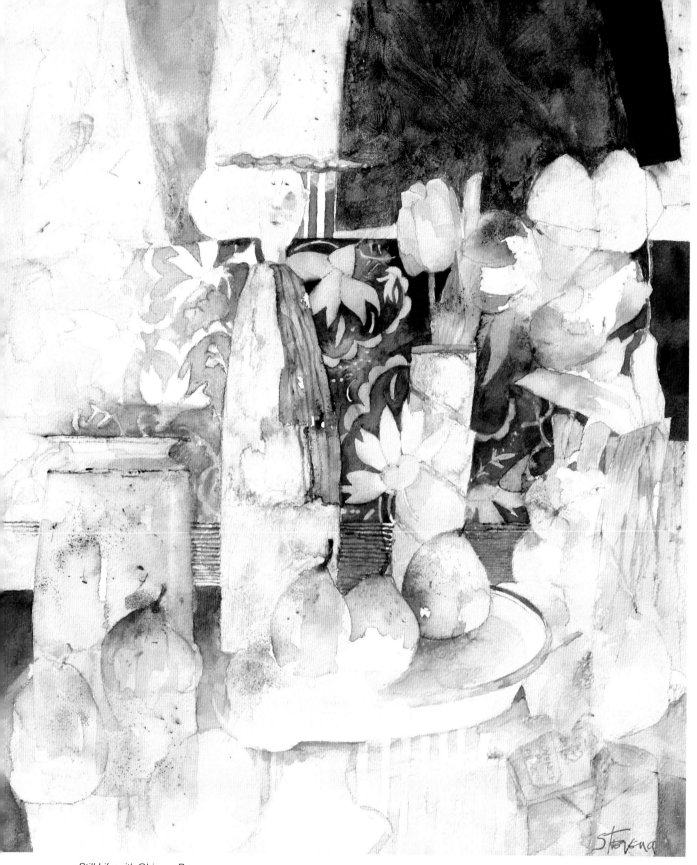

Still Life with Chinese Pears
46 x 38cm (18¼ x 15in)

Using pears as favourite objects

If we have pears in our fruit bowl at home I can't resist drawing them or thinking through a possible still life in which I could use their fabulous shapes and colours. I find both their skin and flesh inspirational. Here are some of my paintings in which I have lovingly added them to a still life.

Fruit Bowl with Pears and Orchids
48 x 38cm (18¾ x 15 in)

Three Pears
30 x 40cm (11¾ x 15¾in)

Fish Vase with Red Pears
38 x 48cm (15 x 18¾in)

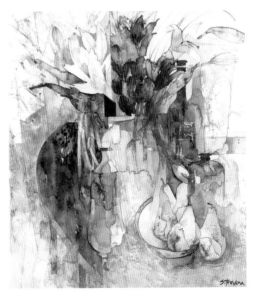

Pink Pears, Red Flowers
55 x 48cm (21¾ x 18¾ in)

Going for green
Summer French Greens

I can't get excited about green. Am I the only artist who thinks it a bit dull, a bit difficult to use and sometimes a bit trite? I even opt out of mixing green and usually reach for the tubes, my favourites being Olive Green and Perylene Green. I do know how to mix these two but somehow I always try to avoid it, my confidence low when it comes to the dreaded quiet greens.

'To paint is not to copy the object slavishly, it is to grasp a harmony among many relationships.'
Paul Cézanne

The challenge of using green

Summer French Greens is a painting about breaking my own habit of only using a small amount of this elusive colour and never completing a picture where it rules supreme. Not being a landscape painter, I had managed to put this passive colour on hold and get on with the vibrant ones, but while I was living in France I was surrounded by it. Day in, day out, we passed through lush countryside, trees and bushes offering up an amazing versatility of my most unfavourite colour and I was loving it. But was I up to the challenge of a greeny painting? Did I feel that tingle of anticipation that I get when I'm close to being involved in another piece of work? Apparently yes, because I started on *Summer French Greens*.

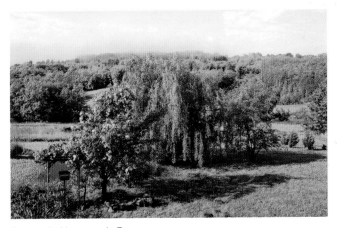
Surrounded by green in France.

Day in, day out, we passed through lush countryside.

Left: Detail from the finished painting (see page 48).

An inspirational pond with goldfish.

Early ideas

The only way I could tackle this subject was to walk round the country lanes photographing all the greens and getting into the right mood to use them as my main choice of colour – and what a choice of greens there turned out to be.

It was the beginning of summer and all around us were fields of lush foliage in colours ranging from the cold green of turquoise to the warmer olive greens. Our large garden was a great inspiration as well, full of trees and other plants and, best of all, a large pond with hundreds of goldfish.

There were hundreds of fish, seen here waiting to be fed.

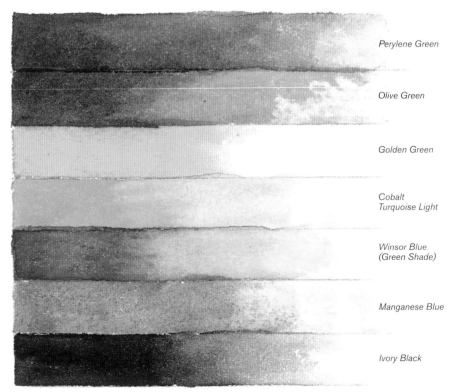

Perylene Green

Olive Green

Golden Green

Cobalt Turquoise Light

Winsor Blue (Green Shade)

Manganese Blue

Ivory Black

Colours used in *Summer French Greens*.

First marks

My starting point was the garden pond, but shown as bowl-shaped as if it had been sliced in two and I could see its inner layers. This I painted a sludgy green-brown and then scratched through the paint with a bamboo stick while it was still wet to portray a lot of activity and a feeling of things growing in the pond. The top of this bowl shape gave me a central horizontal line, which I carried across the paper to give me a good spatial division in the composition (see page 48).

Hovering over the bowl is a sweep of black. It really is black – Ivory Black, in fact – and where it joins this horizontal line I painted some random rock-like shapes which lead up to two pale yellow-green semicircles. These echo the pond shape and suggest two trees. Beyond these, to the extreme left, is what could be the trunk of a silver birch. It's so pale you hardly notice it and there are no branches or leaves to explain it further. To the right of the pond I made various marks to suggest grasses and rushes.

Before I did this I experimented on bits of paper with scratching tools such as bamboo and sticks to find which would give me the look that I wanted of reeds and rushes pushing up from the water.

The colours ranged from the cold green of turquoise to the warmer olive greens.

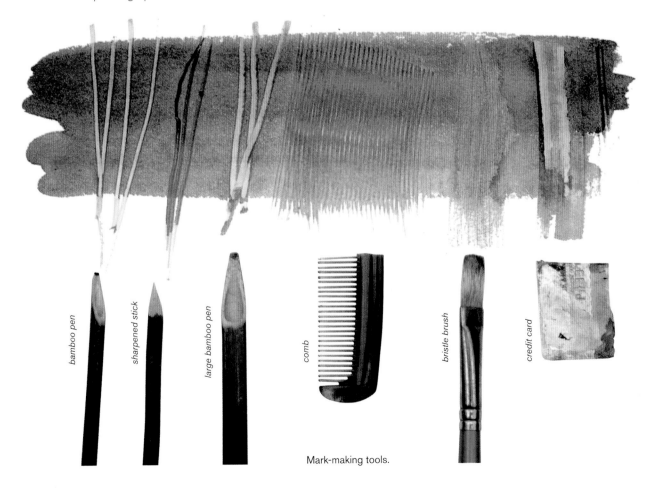

bamboo pen

sharpened stick

large bamboo pen

comb

bristle brush

credit card

Mark-making tools.

Moving towards abstraction

The remainder of the painting is made up of random shapes rather like a patchwork quilt, each section textured in a different way that represents various types of vegetation to be seen at the height of the summer in this area of France.

We had visited a local beauty spot – Domme, a medieval town with a high viewing platform, which gave us a fantastic panoramic view of the Dordogne countryside. There were no hedges or walls to divide the fields so each geometric shape ran smoothly into its neighbour, with just a subtle change of colour and texture. Looking at all these wonderful green geometric shapes, I was amazed at how abstract the landscape appeared. As usual when I see something like this I had no camera or sketchbook with me, not even an old envelope to scribble on. I hadn't started this painting at that particular time but I stored up the view in my mind. I knew I could use it later and now was the time.

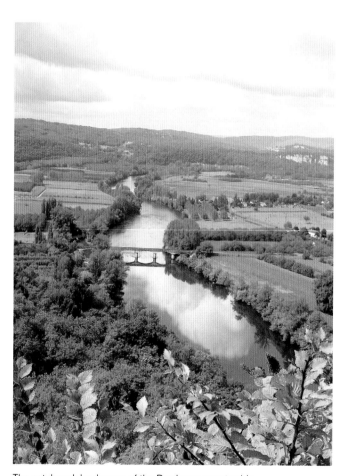

The patchwork landscape of the Dordogne countryside.

Pulling it all together

The final days of working on *Summer French Greens* made up the most exciting part. That was the time I could stop worrying about my composition and choice of colours and start thinking about the last few marks – the tweaking that makes a painting come together in an exciting way. What I had already painted needed to be strengthened by heightening the colours, and for this I used my oil pastels.

Yellow pastel lines bounce across the stones.

The use of blue oil pastel strengthened the colour.

At this stage the marks are usually intuitively made; I just feel the need to add a touch of a different colour or darken different areas, although once these additions are made it's quite easy for me to explain what they have added to the picture. The strong blue line under the pond shape could be water leaking into the undergrowth, while the yellow pastel lines bouncing across the stones could be flashes of sunlight. But these were all quite randomly made marks.

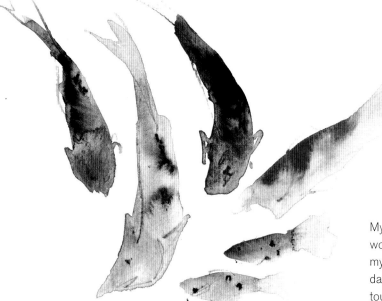

Feeding frenzy for the goldfish.

A flash of red was small but very important.

My last little flourish was the addition of that wonderfully rich red flash across the bowl shape, my intended suggestion of hundreds of goldfish dashing across the pond to be fed. A brilliant touch of colour placed in exactly the right spot can pull everything together; it can make the whole painting sing and was clearly needed here. At that moment I knew the painting was finished. I could come back later in the day or in a week or even a month to take a fresh look at the work and see that I did stop at the right moment when everything was resolved.

Enjoying the moment of painting

My aim with this painting was to portray the never-ending greenness of the countryside and to express the powerful emotions I was experiencing, living in another country in a house miles from a village or even any neighbours. My friends said I would only last a couple of months if there wasn't a shoe shop around the corner. In analysing my feelings at that time I realize I was surprised to feel so safe and secure in those strange surroundings and this is quite a soft composition. But there is also an edginess about it, a sense of everything growing like mad around me while I sat quietly sipping my tea.

The fluidity of watercolour

I find that watercolour lends itself well to creating marks of personal expression; when you are working gesturally the paint flows freely and can reflect your own mood. Once I have removed myself from literal observation I am forced into thinking in a more expressive way. I find the painting gets its own life after a while, demanding colours and shapes that I just hadn't planned on using, but were so right for that moment. Unfortunately the more conscious effort that you put into a painting like this, the tighter the mark-making becomes. You really have to relax and enjoy the moment of painting. I managed to complete 10 paintings in this style before I began to over-plan, became cautious with the paint and the pictures got tighter. Then I knew it was time to stop my diversion into abstract landscapes and move on.

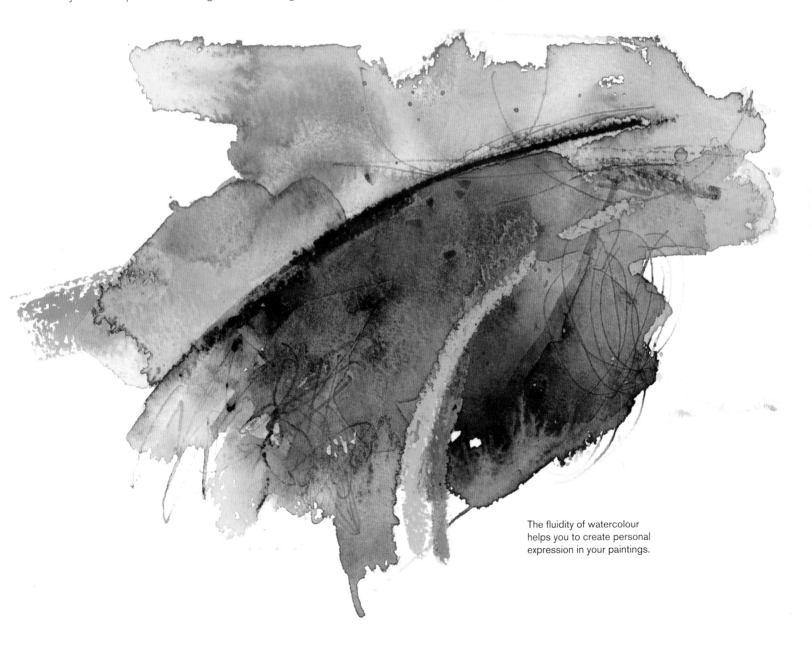

The fluidity of watercolour helps you to create personal expression in your paintings.

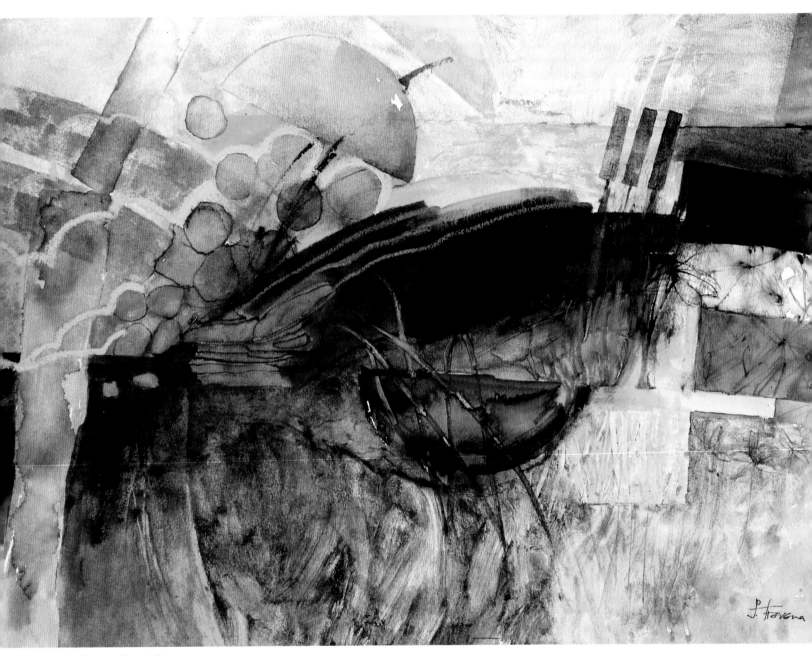

Summer French Greens
43 x 59cm (17 x 23¼in)

More French abstracts

These three paintings were completed over a few months, but in the final composition, *Castelnaud*, I was already moving away from abstraction by bringing in the more realistic house shapes.

Castelnaud
45 x 40cm
(17¾ x 15¾in)

October – Castelnaud
53 x 39cm (21 x 15¼in)

Hot Rocks
41 x 46cm
(16 x 18in)

Breaking the rules of perspective
Still Life with Yellow Paper Bag

When I made up my mind that I wanted to learn how to paint, I started on a couple of little pictures of butterflies and apples – but it didn't take me long to realize that realism was not for me. I didn't want to paint an accurate representation of what was in front of me; I became far more interested in only taking inspiration from my subject matter. In practice it meant combining several views of the object, which could be all more or less superimposed. It expressed the idea of the object rather than just giving one view of it.

To make my compositions work, every object has to relate to its neighbour in its shape or its colour and if this means I have to paint a cup upside down or a little blue tree than that's what I have to do.

'All painting, no matter what you are painting, is abstract in that it's got to be organised.'

David Hockney

Talking about Cubism

I have this picture in my head of Picasso and Braque sitting in a Parisian café drinking wine. It is the early 1900s. On the table are two wine glasses, a bottle, a pipe and a newspaper. They are quite silent, then after gazing at the table for several minutes Picasso turns to Braque and says 'I've just had a really good idea for a painting.'

'I've just had a really good idea for a painting.'

Left: Detail from the finished painting (see page 59).

I'm sure that the birth of Cubism required the shedding of much more blood, sweat and tears than just a quiet little get-together of two working artists, but whatever happened in their discussions, Cubism was about to come into being. It was to take a huge step away from Western ideas of perspective and would deal with the ideas of fragmenting surfaces and spatial flow, imitating that fleeting nature of sight as your eyes dart across the surfaces of the subject matter.

Going all Cubist

Since my early still-life painting adventures I have often touched upon these ideas. In *Lunch Table* (left) the perspective rule is definitely broken down. It is a two-dimensional painting, the objects placed firmly on the surface of the paper with the background advancing to interact with the table.

The crockery, fruit and so forth are distorted and displayed on a tabletop that doesn't quite balance on its legs. We can see the surface of the delicate tablecloth and even the cup at the back of the table appears to be on a level with the foreground grapes and oranges. The striped rug underneath the table appears to be hanging at right angles to the floor, giving no traditional perspective lines to draw the viewer into the picture.

Lunch Table
48 x 38cm (18¾ x15in)

Setting up the still life

I wanted this painting to explore the ideas of fragmenting surfaces and to use objects and space in a closely confined way. To do this I had to flatten the objects and bring everything to the surface of the paper.

In my collection of props I have several vases and many of them contain paper, silk and wooden flowers that I can't help collecting when I go to garden centres. You just never know when you might need a pale pink tulip, for example! For this painting I chose some bright red silk amaryllis and twigs with red berries made out of twisted paper and wire. These twigs make wonderful shapes and you can bend them to suit the composition. I have used them in several paintings in the past.

I wanted this painting to explore the ideas of fragmenting surfaces and to use objects and space in a closely confined way.

Props in the studio, including the red amaryllis.

Willow Jug with Paper Flowers
40 x 40cm
(15¾ x 15¾in)

This painting uses the same flowers and twigs as *Still Life with Yellow Paper Bag*.

Once I had decided to use the vibrant red of the flowers I knew the painting should be based on reds, blues and purples, but the big questions were where I would place this still-life set-up and what would be in the background. 'How do you do your backgrounds?' is the question I am asked over and over again.

For me, backgrounds are not an afterthought as to how to fill in all the spaces around my objects when I get to the end of the work – they are taken into consideration at a very early stage of selection. If I'm not inspired by any position in my studio for a particular painting, if I'm not excited about the view from the window or of the appearance of a table top, then I choose something suitable to place behind my objects from my collection of fabric and carpet samples; failing that, even tea towels or wrapping paper are considered. Everything that is displayed in front of me has to be chosen for a sense of unity, be it of colour or shape.

The square of pale blue and pink paper shown right was cut from a magazine and pinned to some Indian cloth (below). You can just see the red head of the pin. If I can't find an object with the sort of pattern I have in mind, cards or cut-outs from magazines can be very useful.

A section of the still-life set-up, showing a magazine cut-out and some paper twigs with berries.

An Indian patchwork quilt.

For the background of this painting I wanted some fabric that was purple or blue and would sing with the vibrant reds. It also had to have an interesting pattern that I could weave and blend into the shape of the chosen objects. This patchwork Indian cloth (left) has palm trees and elephants appliquéd all over it – perfect information to use in my background and foreground.

For me, backgrounds are not an afterthought as to how to fill in all the spaces around my objects when I get to the end of the work.

The final set-up

In the final set-up I included a golden pear and a red bowl to add some organic shapes contrasting with all the verticals, and the little book sat nicely at the base of the picture. The vase was plain glass and I needed it to be white, so I cut out a rectangle of white paper which I attached to the front of the vase with double-sided tape. The pinkish-purple bag was plain, so I selected some random lettering cut from a magazine and that was attached to the bag just to give another little Cubist touch of cut-out letters to add to the composition.

The final set-up.

Techniques used

Making a decision on colour choices was easy for this painting once I had picked out the red paper flowers and the Indian cloth. I knew there had to be hot reds moving from Brown Madder to pink, the blues would move from purple to turquoise and there would be a touch of green and yellow – although I could easily change my mind on that later.

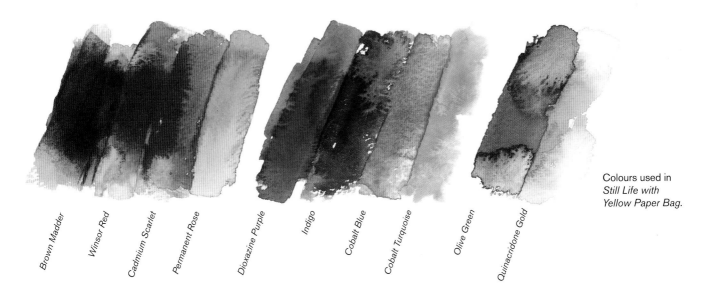

Brown Madder Winsor Red Cadmium Scarlet Permanent Rose Dioxazine Purple Indigo Cobalt Blue Cobalt Turquoise Olive Green Quinacridone Gold

Colours used in *Still Life with Yellow Paper Bag.*

The red flowers had
to be vibrant and they
were the first things
I painted. With large
flowers such as these
amaryllises I always
like to start with a petal
that appears to have a
straight side. I love to
exaggerate a tightness,
a tension of a straight
against an organic line.

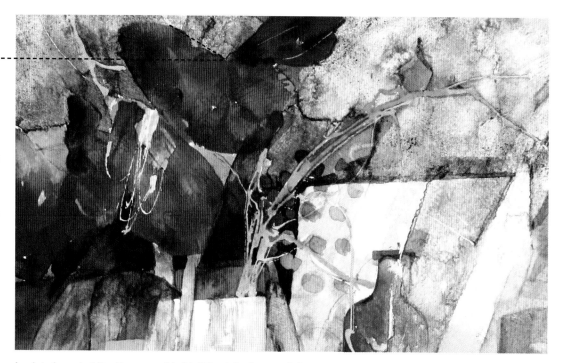

I painted most of the flowers red but left the tallest one a delicate
pink. I then decided where I would place the horizontal lines formed
by the top of the bag, vase and magazine cutting to make a strong
focal point that would draw the viewer into the red of the flowers.

I extended the etched pattern on the bottle.

Now I could put down masking fluid for the twigs and berries,
the small dots moving down to join the patterned dots on the
paper cut-out.

Once the vertical objects were painted I concentrated on the
white jug, tipping it to change the viewpoint and to display
the beautiful handle and lip. The purple glass bottle was
completed with multiple layers of thin watercolour. It now
leans to the right towards the jug and the etched pattern on
its base has been extended.

At this point I reached the lower edge of the stretched paper.
I had run out of space, a hazard of not drawing first, and
because of this the bowl, pear and book had to go.

Stepping away from accurate visual representation

A part of me wants to show my viewer the subjects that I have chosen, but I am not interested in their accurate visual representation. My aim is to produce an image that has a structural and harmonic nature in terms of colour and design. Parts of the painting can be easily read while other parts are mysteriously hidden.

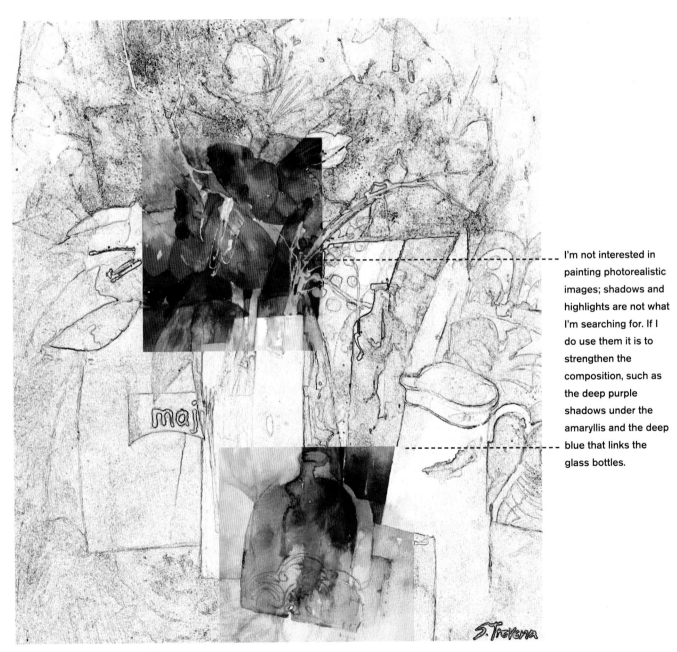

I'm not interested in painting photorealistic images; shadows and highlights are not what I'm searching for. If I do use them it is to strengthen the composition, such as the deep purple shadows under the amaryllis and the deep blue that links the glass bottles.

The darker shadows in the painting.

The main decision I had to take was what colour to make the paper bag. Rather than painting this first I cut out some cool pink paper to see what would happen if I were to use its original colour. Doing this made me realize that pink was the wrong colour, isolating it from the flowers, and so I went ahead and painted it golden yellow. The bag now connects to the red flowers, the warm side of the painting, and not as it is in the picture shown right, where it moves across to the blue, cold, side of the composition.

I also realized the white vase appeared to step forward from all the other objects and was destroying the flatness of the surface. By painting it pink I made it relate to the right and left of the painting.

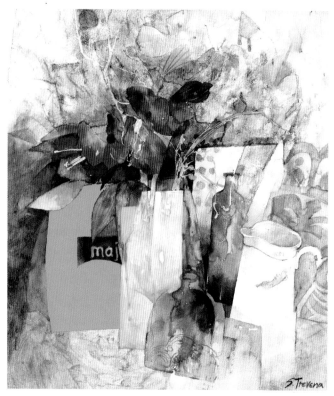

My original idea of a pink bag.

The absence of a preliminary drawing means that I have to compose a purely mental image of what my painting may become. This painting demonstrates how that approach allowed me to be much more able to change my concept in midstream and reject some of my still-life objects.

This final arrangement on paper does partially resemble the actual still-life set-up, even though I have omitted several pieces of information and I know the painting has evolved quite differently from my original idea. The colours are quite transparent and overlapping so that they shine through one another to represent light without having to reproduce it.

The landscape abstractionist Richard Diebenkorn once said 'I can never accomplish what I want, only what I would have wanted had I thought of it beforehand.' I do share his belief – I can never predict what can happen in a painting. I can do a bit of planning or a lot of planning, but I also have to let my unconscious impulse take over at some stage.

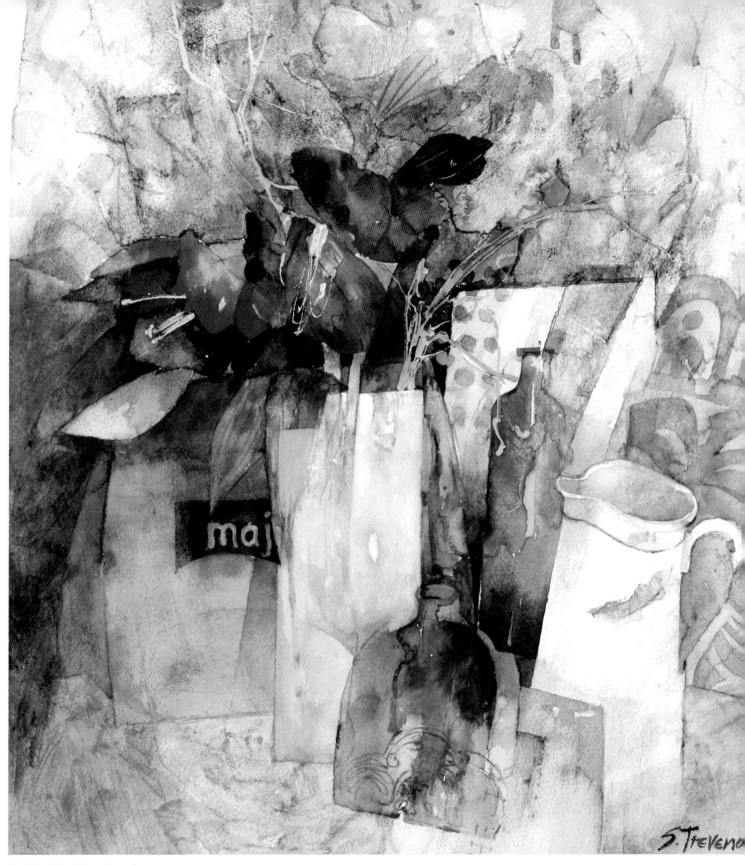

Still Life With Yellow Paper Bag
45 x 39cm (17¾ x 15¼in)

The happy accidents of watercolour

Scottish Waterlilies

The unpredictability of watercolour is a valuable tool for the artist, giving rise to marks and colour blends that were never intended but add enormously to the success of the end result. Painting *Scottish Waterlilies* gave me a perfect opportunity to see just what the mix of a lot of water and paint would accidentally produce.

I always have it in mind that overworking can be destructive, especially when I am aiming for spontaneity as I was in this painting. I keep checking my work carefully when I come to moments of indecision to see if I have already accomplished what I set out to do. With this painting further work just meant adding more accidental dots and drips.

> '*I have always tried to hide my efforts and wished my works to have the light joyousness of springtime which never lets anyone suspect the labour it cost me.*'
>
> Henri Matisse

Discovering happy accidents

When working with watercolour I enjoy creating glorious messy accidents – drips of paint, colours flowing into each other and, best of all, the 'cauliflower' marks that so many painters try hard to avoid. For me, all these invited 'accidents' make a huge contribution to my paintings, giving me the sort of marks I could never plan and bringing an element of risk into the actual execution of the work. Accidents can dictate the direction a painting takes and this is one of the unique properties of watercolour – beautiful things can happen inexplicably.

Left: Detail from the finished painting (see page 66).

A waterlily pond is a perfect subject for this medium, with lots of water dripping everywhere and giving me a chance to paint layer upon layer of colour to suggest the depth of the pond, along with inventing ways of making textural marks to break up the surface. This unique ability of watercolour to granulate, settle and blend can still surprise and delight me.

Inspiration in a Scottish garden

My friends Aileen and Mike live in Scotland and my first visit to their house in Glasgow was to be quite inspirational. Aileen is also a watercolourist and our conversation about the highs and lows of using this tricky medium was like recharging my batteries. After I had looked at the work in her studio she said she had something in the garden she wanted me to see. It was a beautiful lily pond and the moment was perfect for us, standing and staring at the circular green and yellow leaves and the luscious pink flowers. It was a clear blue sky day, with reflections in the water throwing back mysterious layers of blues and greens. I do remember saying, 'I'll get my camera.' The inspiration for my next painting had arrived.

This was my first view of the waterlily pond. The sky reflected in the water produced subtle blues and greens.

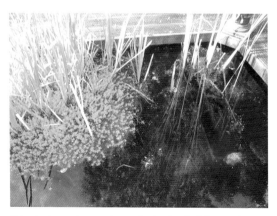

This photograph was chosen for its detail of the reeds at the top of the pond.

Planning the painting

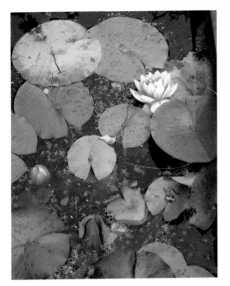

My reference photograph for the placing of bigger leaves at the top of the picture.

With several photographs of the lily pond in front of me it was difficult to choose 'the one', the perfect composition. What looks just right through the camera lens can prove to be disappointing later, perhaps too fussy or boring. I generally end up using bits of information from several images and this is what I did here, leaving out leaves and distracting elements from one photo and adding in flowers and reeds from another. My main photograph has the bigger leaves at the top of the picture, diminishing as they seem to float to the base of the composition. I find that centring the interest close to the top lends a feeling of immediacy to the scene and brings a greater involvement to the viewer. You are drawn up into the lush vegetation at the edge of the pond as if you are floating over the leaves and water.

And so I decided that the structure of this painting would contain strong random marks at the top of the composition to represent possible paving slabs or rocks. The leaves and flowers would float down to the quieter lower half and I would use the natural colours of the waterlilies which were quite delightful, though I would need to heighten them, exaggerating the strengths of the blues and greens.

What looks just right through the camera lens can prove to be disappointing later, perhaps too fussy or boring.

The actual size of my final thumbnail sketch is only 8 x 12cm (3¼ x 4¾in). For me it is a perfect little picture, the sort of drawing that can come so naturally when you know it's only a sketch. It won't be framed and may even get thrown away after the painting is completed. Now all I had to do was transfer it to bigger paper and still keep it fresh.

However, transferring sketches from small to large is a real headache for me. I needed to keep that edginess, with the shape of the leaves interpreted in an interesting way – and of course working with pencils and crayons gives you lovely jagged marks that are hard to reproduce in paint.

My preliminary sketch.

Experimenting with paint and graphite pencil

After a lot of experimenting with all my brushes and sticks I decided that watercolour with graphite pencil would produce the marks I needed to show a harder, cold surface at the top of the painting. Using a texture medium as a base and letting it only partially dry, I experimented with smudging graphite and paint. I then scraped through the whole thing with a chiselled bamboo stick to get some stem-like shapes.

Watercolour and graphite pencil produce a hard, cold surface ideal for suggestiing rock.

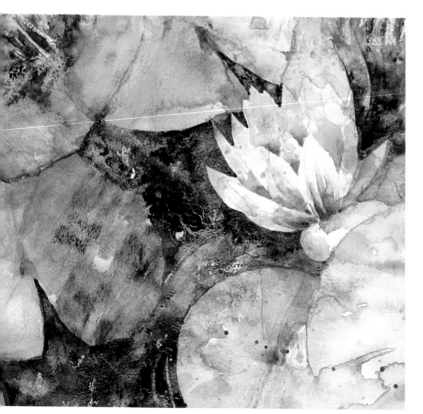

My choice of colours ranged from a wide selection of blues and greens to some warm pinks and orange-yellows.

Starting the painting

For this painting I was going to have to use a lot of water to get those marvellous happy accidents and so I chose a heavyweight paper – 638gsm (300lb) – with a NOT surface. I always work straight on to dry paper then add the water to the paint, so I didn't have to wet my paper before I started and as this was heavy paper no stretching was required. I would use a wide range of greens and blues and keep it fairly simple with just the warm pinks and the orange-yellows.

My starting point was the very top of the composition. I had to get those texture marks right – I had achieved them in the thumbnail sketch and in my experiments, and now I had to reproduce that on my large piece of paper. This part took a lot of patience. The graphite pencil marks had to be partially rubbed away then smudged with water, which was mostly done with cloths and my fingers. The reeds were initially a lot of paint, then while they were very wet I took my bamboo sticks and scraped through the point before using the graphite pencil again to get some depth to the stems. After a lot of pushing the paint about and adding fuzzy pencil marks I waited until it was completely dry and then gently painted a light turquoise over the whole thing. I only got one go at that process – any more would have obliterated the marks. A light hand is needed for this sort of technique.

Moving down from the rocky pond edge, I started the placing of the lily pads. I knew that was important in getting this composition right, so I felt the need to do some preliminary pencil marks. I had got them placed correctly in the sketch, I liked the composition, and now I wanted to transfer that to the larger format. I lightly drew all the ellipses and circles with a red watersoluble pencil; you can just see the outline in some places. That's the beauty of these pencils – as soon as you paint over them you are left with tiny pieces of their colour still shining through. Then I used a small amount of masking fluid to reserve white paper for a few dots and some reeds that would appear in the foreground.

I think for me the secret of painting a large picture of just flowers is to have patience. I started at the top of the composition and worked my way down; each leaf was only partially painted, left to dry then more paint applied and so on, causing all the random edges to dry and make wonderful accidental marks. Puddles formed and I added other colours while they were still wet, dragging sticks and watersoluble pencils through the paint. I had to walk away from the painting to let each piece dry completely and on returning hoped that miracles had happened which I could never have planned but which were perfect for that watery look.

I used red soluble watercolour pencil to sketch in the outlines of the lily pads.

The perfect medium for happy accidents

Although this painting looks unplanned and very loose, in reality it's a mixture of carefully painted outlines and soft, wet accidental marks which create a tension between the leaves and take the viewer on a walk through all the wet, glossy waterlily pads and delicate pink flowers, right up to the grey of the stony edge of the pond.

It is in fact a straightforward painting of waterlilies; the viewer can recognize the subject matter immediately. What I have tried to capture is my initial delight at seeing these wonderful plants. It is a good example of the medium fitting the subject matter and showing the magical properties of watercolour paint.

An unhappy watercolour accident.

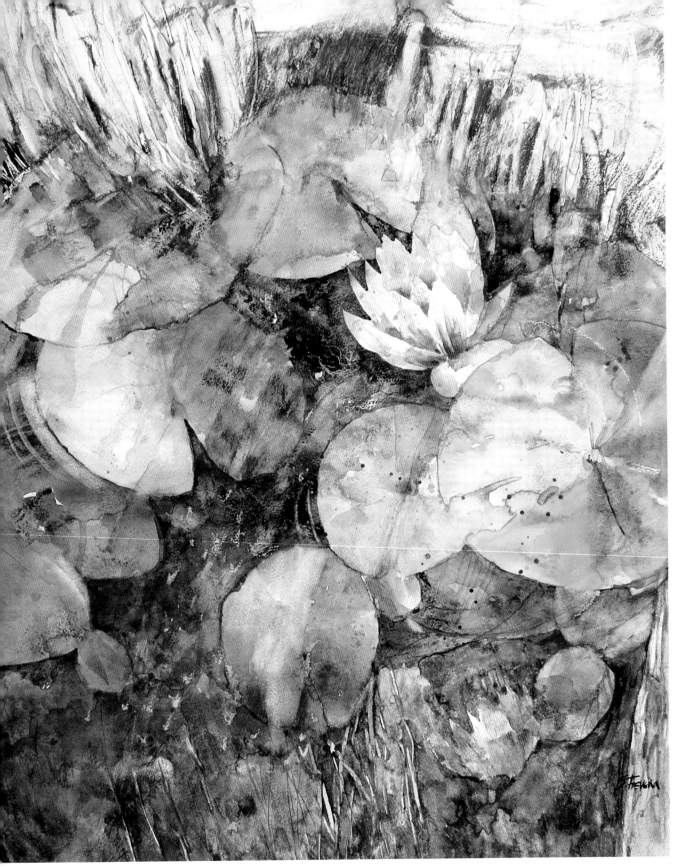

Scottish Waterlilies
70 x 60cm (27½ x 23½in)

Paintings that also show the magical properties of watercolour

These four flower pictures are all painted using NOT surface watercolour paper on a flat surface to allow pools of water to form and dry, giving magical accidental marks. The medium perfectly describes the delicacy of petals and leaves.

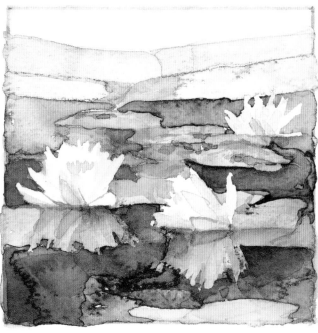

Waterlilies
10 x 10cm (4 x 4in)

Irises
10 x 10cm (4 x 4in)

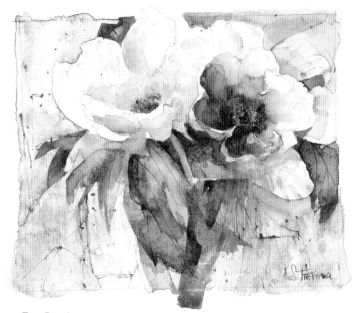

Tree Peonies
19 x 23cm (7½ x 9in)

Convolvulus
18 x 26cm (7 x 10¼in)

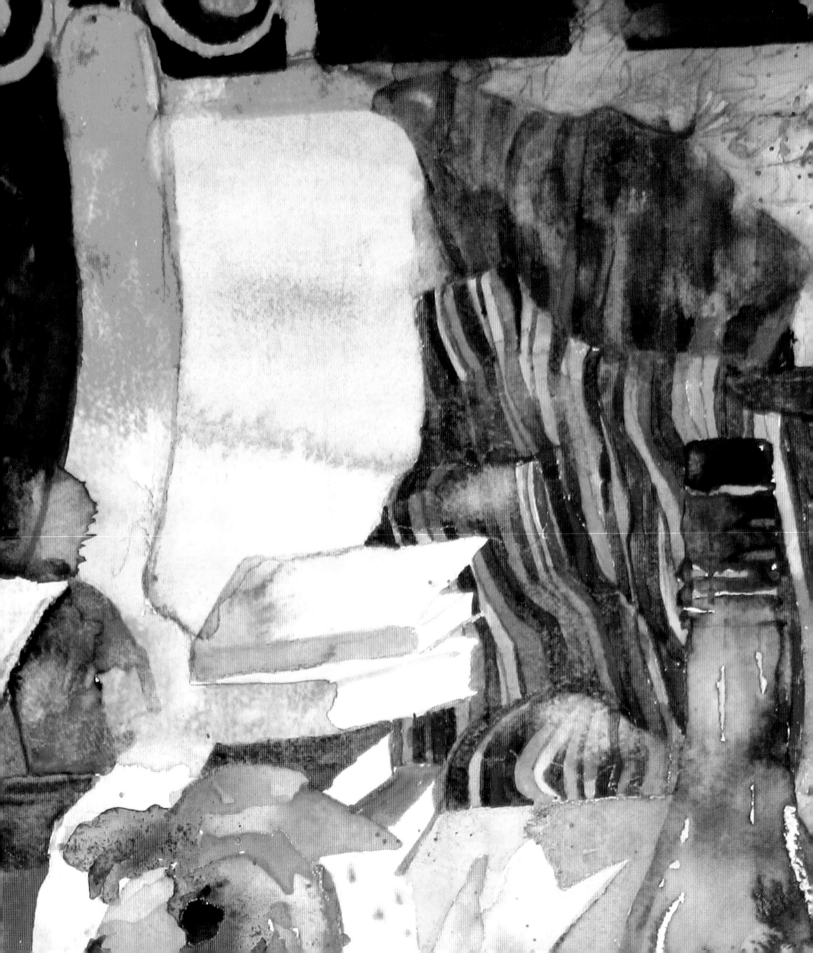

Painting a sunny day

Drinks in the Garden

To create an impression of a sunny day, you don't have to paint a golden globe in a bright blue sky with deep purple shadows to tell the story. Basically, a bright, crisp, sunny day can be expressed by equally bright, crisp, sunny watercolour devices. A suggestion of light can be created from colour and form and the right subject matter.

> *'The moment you cheat for the sake of beauty you know you are an artist.'*
>
> Max Jacob

What shall I paint next?

For my next painting I wanted to step back from a close-up still-life piece and go outside to capture some fresh air and sunshine. A summer garden scene would be perfect.

To do this I needed to think hard about my choice of colours if I was not actually going to show blue sky and deep purple shadows. I needed quick, decisive brushwork for crisp strokes, intense, vividly contrasting colours and marked value changes. Most of all I needed to leave flashes of white, accents created by the whiteness of the unpainted paper – there is nothing brighter than pristine white. In the end my choice of cool blues and greens occupied as much space as the warmer colours usually associated with a bright hot day.

Manganese Blue

French Ultramarine

Cobalt Turquoise Light

Green Gold

Hooker's Green

My choice of cool blues and greens.

Left: Detail from the finished painting (see page 76).

An inspiring place to start

Glancing through a magazine for ideas, I came across a picture of a garden bench in front of some dark foliage. It was the colour combinations that excited me, with the metal bench and railings painted a strong manganese blue against the dark green, almost black, leaves – a wonderful combination of vibrant colour shapes with dark negative spaces.

This would be a perfect base for my garden picture, so I prepared a collage of pieces torn from the magazine. I found greeny grass on one page, books and pillows on another and then random pieces for the foreground.

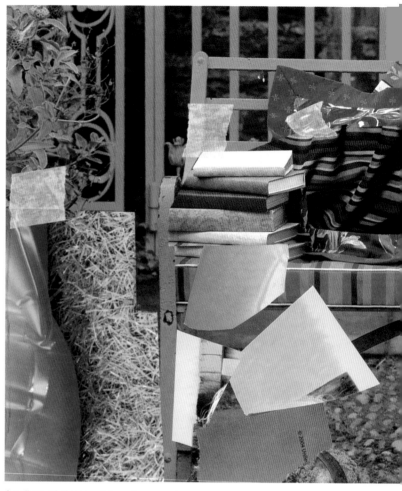

A collage of pieces cut from the magazine.

This magazine picture gave me an idea of a colour range for the rug.

Preliminary sketch

My collage assembled from various pieces of paper gave me all the information I needed for the top half of the composition. I just changed the pillows into a rug with stripes running vertically rather than horizontally to stop the composition from shooting off to the right and set up some interesting vertical lines.

The lower half of the composition was more of a problem. I had to bring sunlight into this section, since from the collage I could see the picture still looked a bit dark and gloomy. This meant I needed a lighter touch in the lower half of the painting and to leave some bright white paper to shine out.

If I have been inspired by a small section of a photograph as I have with this painting, the difficulties arrive when I only have reference for part of the composition. I do like to start work with most of my information sorted out. That may mean a small sketch or a complete still-life set-up in front of me. I need a plan for how I am going to fill the paper. Of course the plan may go out of the window very early on, but that's better than getting halfway through the painting and feeling I have jumped into the deep end of the pool without my waterwings.

To complete my reference material I made a sketch of an idea as to how I could solve the problem of the lower half of the painting. My starting point would be a plant pot on a garden table, bringing in some light with pale blossoms and strong leaves leading up the composition. Now I could start to paint.

I do like to start with all my information sorted out.

My first small, rough sketch.

Putting the paint down

Even though I hadn't made a final decision about what would be in the foreground of the painting I decided to start with what I liked best and was sure about. This is always a good idea for me, thinking that the rest will fall into place later — my usual attitude to not being quite sure about a section of the painting.

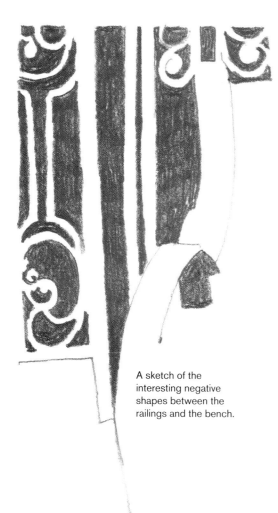

A sketch of the interesting negative shapes between the railings and the bench.

This time I began with a light sketch on the paper, showing the outline of the railings and side of the bench. Those negative shapes were important to the composition; I had to get them right. The blue and black shapes were my main interest in the original photograph so I laid down the strong blue first, putting a lot of water on the colour as I went, letting it partially dry then adding more water to blur it and create texture.

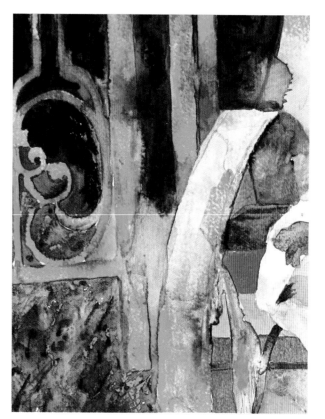

Paler green and blue brought light on to the armrest.

I was particularly interested in the armrest of the bench. The photograph didn't do it justice so I took a more sideways view of it, turning it into a beautiful curve. This section was now ready for the darks, a mixture of Hooker's Green and Ivory Black. I was not painting it with solid colour but texturing it with small areas of lighter green, bringing the light in. The top of the armrest was left a paler blue, again bringing the light in and pushing its wonderful shape forward in the composition.

Next came a suggestion of the books, but much smaller and paler than in the collage. After that, I had my chance to start work on the striped cloth. I kept the original strong colours of reds and blues and partially painted the cloth into a triangular shape to tumble down towards the table, linking the upper half of the painting with the lower section.

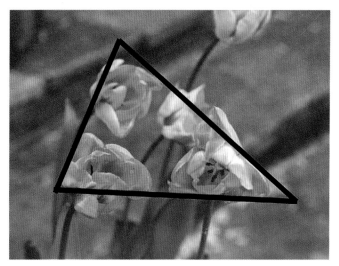

These tulips, photographed in my garden, form an interesting angular block.

I couldn't put it off any longer; I had to make a decision about the foreground. I decided on a pot of tulips and looked through my folders with floral information. I came across the photograph of tulips taken in my garden that I had used in the painting *Red Flowers and Figs at Rauffet* (see page 91). The angular shapes and positioning of the four flowers still intrigued me, so I decided to use the image again for this garden painting. They have been painted quite boldly, with oversized blooms advancing towards the viewer. Their colours move from pale diluted Winsor Yellow to Perylene Maroon, so they play a large part in bringing a golden light into this picture.

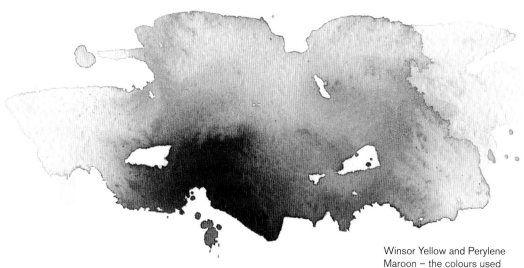

Winsor Yellow and Perylene Maroon – the colours used for the tulips.

The top of the armrest was left a paler blue, again bringing the light in and pushing its wonderful shape forward.

Before I could paint the flowers in their final position I needed to draw out an idea for the layout of the table to get some shapes on the right side of the painting that would interact with the flowers. I set up a small still life with bottles to give height leading up to the cloth, some shiny glasses and a bowl.

Looking at my preliminary sketch again, I realized that to revert to the darks with the flowerpot would make the composition unbalanced. Only the leaves were needed to sit at the bottom edge of the paper. This white table was where the sunlight shone out. It needed to be bright enough to bounce light off the paper and to make the bottles and glasses gleam.

My drawing of a small still-life set-up. These shapes would be used in the final composition.

This white table was where the sunlight shone out. It needed to be bright enough to bounce light off the paper.

I checked out my decision to place a dark flowerpot at the base of the picture and realized a rethink was needed.

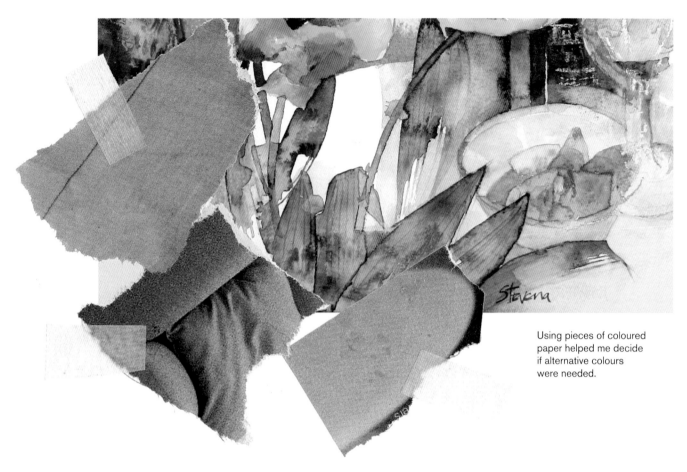

Using pieces of coloured
paper helped me decide
if alternative colours
were needed.

Having worked from top to bottom on this painting, simplifying the lower section was
more or less my last decision. To be sure that leaving the white paper was correct,
I cut out various pieces of paper to find an alternative colour. There was always the
possibility that bringing in a new colour at this stage could lift the painting, giving
it added excitement. However, reserving white paper turned out to be the right
thing to do.

A touch of sunlight

Subject matter is obviously the clue to communicating a mood of relaxed leisure
time to the viewer. I wanted *Drinks in the Garden* to suggest a summer day with its
strong, cheerful colours and areas of sparkling white. The juxtaposition of typical
summer garden furniture and utensils creates movement and a lightness of touch in
the warmth of the afternoon.

When I look at this painting it reminds me of lazy afternoons in the garden, a good
book to read, a cold glass of wine and sun glistening off all the shiny surfaces.

Yes, but is it finished?

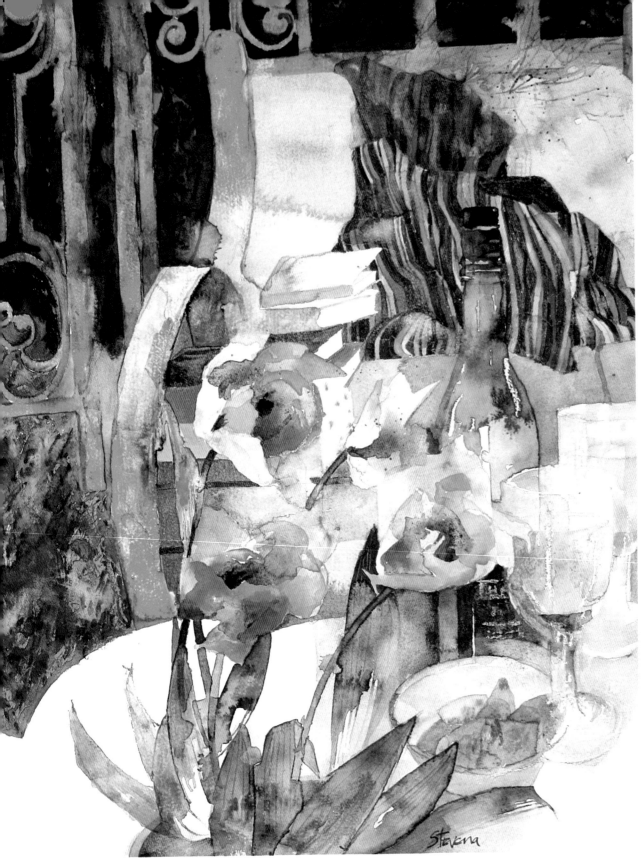

Drinks in the Garden
48 x 38cm (18¾ x 15in)

Sunshine paintings

The paintings on this page also show how the effect of sunlight can be created by using pure colour and letting the white paper shine through.

Espresso, Tuscany
10 x 10cm (4 x 4in)

Light and shadow are implied here by splashes of colour and the deep blue beneath the white table top.

Sunshine and Daffodils
10 x 10cm (4 x 4in)

Sunshine is not only in the colours here but in the association of daffodils with spring.

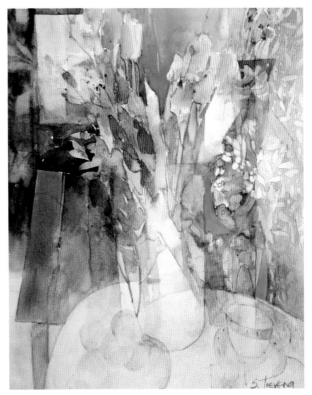

Blue Table with Flowers
47 x 38cm (18½ x 15in)

Little sparks of white paper and the transparent glass vase bring light into this painting.

Lace Tablecloth
30 x 20cm (11¾ x 8in)

The whole painting is flooded with light, half of which is the bare white paper.

Creating a mood – abstraction
Night Fire in France

Seeing a night fire in France inspired me to try my hand at capturing the mood of that scary experience. Part hot, part cold, it brought on a mixture of emotions. First I had to conquer my fear of painting landscapes, then I had to give myself permission to be free with my mark-making, to go with the flow and to put down on paper my feelings about that red, blue and black night.

Country living

My comfort zone for day-to-day living was always the excitement of city life, surrounded by people, noise and shops where I could buy essential groceries such as milk at any time, night or day. I felt safe and secure with all that activity. In fact visits to the countryside were seen as scary excursions into the unknown, my mind exaggerating possible dangers. What was lurking in the garden in the pitch black of the countryside? The London streets never got that dark.

But then I gave up my comfort blanket of city life when we rented a house deep in the greenness of the Dordogne. After a few weeks of watching the birds and listening to the frogs I became used to the darkness and the different night noises and began to relax.

However, one winter's night all that changed when a raging fire started in a field uncomfortably close to our house. I had never before experienced the frightening sight of fire at such close quarters and to feel the extreme heat and hear the crackling and spitting of the flames was terrifying. Eventually the fire was extinguished but the shock of it all stayed with me for days, and I came out of it needing to paint the experience.

'An artist does not draw what he sees but what he must make others see.'
Edgar Degas

View from the window.

Left: Detail from the finished painting (see page 86).

Stepping away from still life

For years I have avoided painting landscapes other than attempting to capture the Scottish Highlands and villas in Tuscany on a very small scale with tiny brush marks. The paintings were all very cautious in colour and form, while my approach to still life is much more experimental and bold.

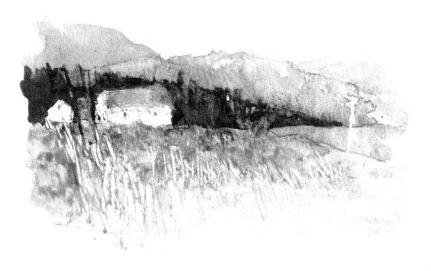

Loch Lochy
11 x 15cm (4¼ x 6in)
I painted this tiny watercolour while I was sitting on a boat sailing down the loch.

Volterra, Tuscany
10 x 10cm (4 x 4in)
This small landscape started life as a pen and ink sketch and watercolour was added later.

While I was carefully putting down paint for expanses of trees and buildings, I realized that the advantage of painting a still life is that you have complete control over your subject and you can play with the viewpoints, the light and the space. But there seem to be no edges to a landscape – it goes on forever, usually all in green.

I needed to conquer this lack of excitement about painting limitless spaces. I had to try to get something on paper, a bigger piece of paper that would take gestural marks and flowing shapes. The fire was a perfect opportunity for me to attempt to capture the mood of the night. I would make it an experiment, not worrying about producing a painting worth framing – I would just plunge in with colour and definitely not do any drawing on the paper first.

There seem to be no edges to a landscape – it goes on forever, usually all in green.

Starting points

My starting point for the painting was to select photographs we had taken of the land and sunsets around our house; they would be the basis for this picture, giving me strong shapes and colours. The sunsets appeared to be like orange and red flames throwing up smoke in the sky. The heat of the picture would be an intense red abstract shape, topped off by a slice of orange filled by swirling black lines. I didn't intend to copy any of the photographs, just observe the colours and loosely pick out shapes which I could translate into my own marks. Several of the photographs interested me and were suitable for the subject matter; these were the ones I wanted to use.

The field shown below was across the road from our house. I often walked past it and one day its surface had completely changed from regimented rows of waving maize to a sweeping pink curve, the tall crop cut away. All that remained were the marks of the tractor wheels creating swirling patterns. I was so fascinated by this I knew I had to use it for the basis of my *Night Fire in France* painting. I liked the fact that all the grasses and plants had been swept away in this field and also in the one that had caught fire.

Moody purples and pinks in the evening sky against the oranges and yellows capture the feeling of the flames and smoke of the fire.

The harvesting of the maize crop left an empty field with interesting tractor marks scoring its surface.

The black silhouette of the trees against the red sky reminded me of the scorched plants and trees we had seen after the fire.

Risking a square format

After considering the information I had gathered I decided on a night theme, black at the top and a dark purple vertical to form a T shape. I had already chosen a square format for my paper, an unusual shape for me because I have found it difficult to complete a composition that pleases me when using it for my still lifes; I always start with high hopes for a strong image but then halfway through I realize the painting would come together much better if I cut chunks off the sides. This normally comes as a last resort and makes me feel as if I have failed to achieve my original concept, but since I choose to do very little in the way of preparatory drawings I accept this is bound to happen at times. For *Night Fire in France*, for instance, I only drew this small sketch to give me an idea of the distribution of shapes and possible colours. I wanted this painting to be more abstract and to choose my various mark-making materials as I went along. The composition did work well in this picture, so it remained a square shape.

The very small preliminary sketch for *Night Fire in France*.

To form a horizon I started by painting a random line across the top of the paper, then two gestural marks to form a large sweeping area that broadened out at the bottom of the paper to follow the photograph of the harvested field across the road from our house.

The area to the right of the picture would contain the fiery elements so, using a graphite pencil, I blocked in some angular shapes with hard edges to constrain the hot colours.

Putting the paint down

I chose Cadmium Orange, Quinacridone Red, Cadmium Scarlet and Purple Madder to portray the heat and the flames, smudging and overlaying them.

I decided against using the deep purple for my large, sweeping area; beside the reds I felt it would become too soft and sweet. The colour had to be a more surprising choice – one with the heat taken out, perhaps an icy colour suggesting the torrent of water needed to put out the fire.

These are the reds that I chose for the fiery colours.

While the paint was still slightly damp I drew in the black stick-like shapes with a large, chunky watersoluble pencil and added some black speckles by scraping the pencil against a sandpaper block. Then I drew into the whole area with a fine graphite pencil and coloured extending shapes and defining areas where the paint had dried, such as the half-circle at the bottom edge of the red area.

My mark-making materials – graphite pencils, watersoluble coloured pencils and oil pastels.

Before I tackled the blue area, I applied a layer of texture medium with a flat bristle brush, let it dry and then painted over it with a watercolour wash. The water makes this texture medium quite pliable so that I could scratch into it with a comb and a broken credit card. My aim was to capture the patterns of the furrows and swirls that I had seen in the harvested field.

Here Cerulean blue is painted over watercolour paper covered with texture medium.

For the sky I used Sepia and dropped in reds and blues. While it was still damp I scraped in a smattering of white watercolour pencil dots to give the impression of smoke.

I extended the blue across the horizon and above that I added a strip of glowing orange and yellow, with a pen and ink drawing of leaves added to it.

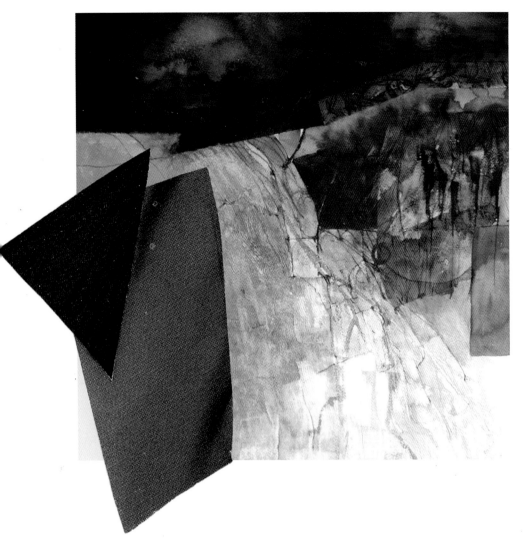

This is always the dangerous stage of a painting for me – more than half finished and there were still big decisions to make, such as whether to add another colour, or put in more detail and, of course, hanging over that the fear of spoiling a piece of work that was moving along quite nicely.

After placing various pieces of coloured paper on to the unpainted area, I decided that there would be no more reds; I would stay with the cool blues and make the red and black areas more isolated and dramatic.

Placing coloured pieces of paper on the work allows me to make judgments about where I should go with my colours without the risk of spoiling the painting.

I often find that playing with paint like this can lead to new responses – I am guided more by instinct.

Finishing the painting

And so I got to the last piece of action for this painting – the application of the details. I decided on a variety of blues for the left-hand side with a strip of red. Then came the fine graphite pencil lines, the textures and the broad strokes of oil pastel, just pushing my pencils around the surface of the paper to create possible tree or house shapes which I took from my photographic references. I added a few dots, finger smudges and the dramatic triangle of golden yellow, which accidentally ended up central to the composition.

I began this painting needing to experiment and feel free with choices. I often find that playing with paint like this can lead to new responses – I am guided more by instinct and spontaneity and after a while play turns into work.

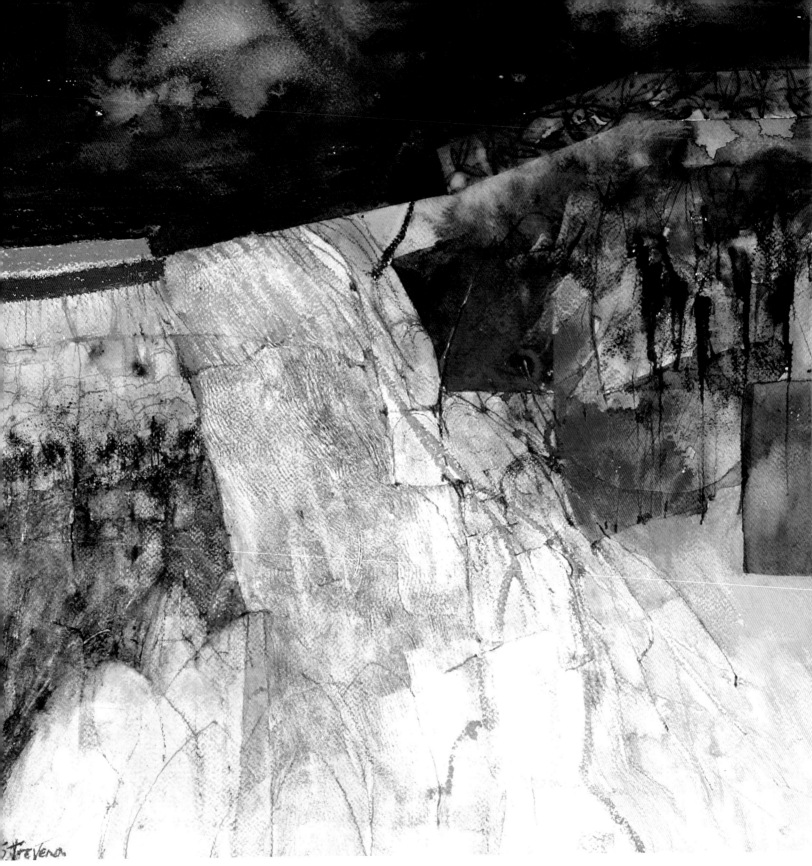

Night Fire in France
48 x 48cm (18¾ x 18¾in)

Capturing the mood of night-time

Sarlat (right) is also a night-time painting. I spent an evening in this medieval French town when its inhabitants were celebrating a European Heritage Day. At night the whole of Sarlat was transformed by floodlit buildings and thousands of candles, turning it into a magical place. I wanted to capture the mood by doing this gestural painting, just hinting at Gothic arches, monumental stone and, of course, dramatic lighting.

In *Night and Day Through France* (below) I wanted to create the feeling of travelling by car through France for several hours, going from night-time to daytime. You can see the dark night sky and the grey of the road with the patterning of the French countryside rushing past our windows.

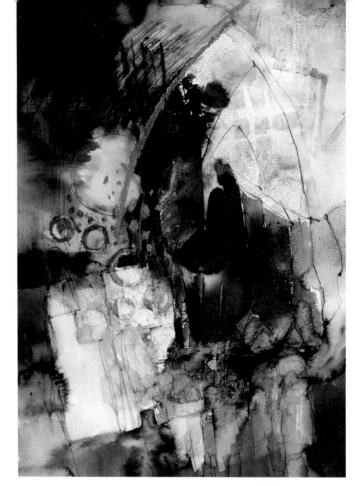

Sarlat
59 x 42cm
(23 x 16½in)

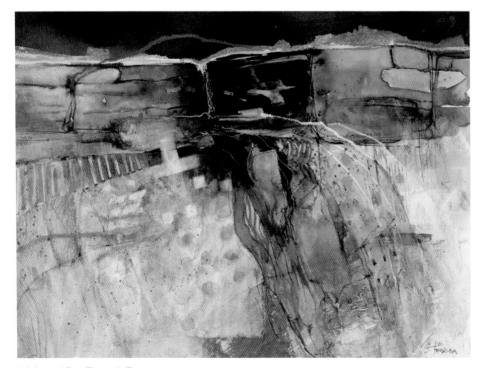

Night and Day Through France
42 x 58cm (16½ x 22¾in)

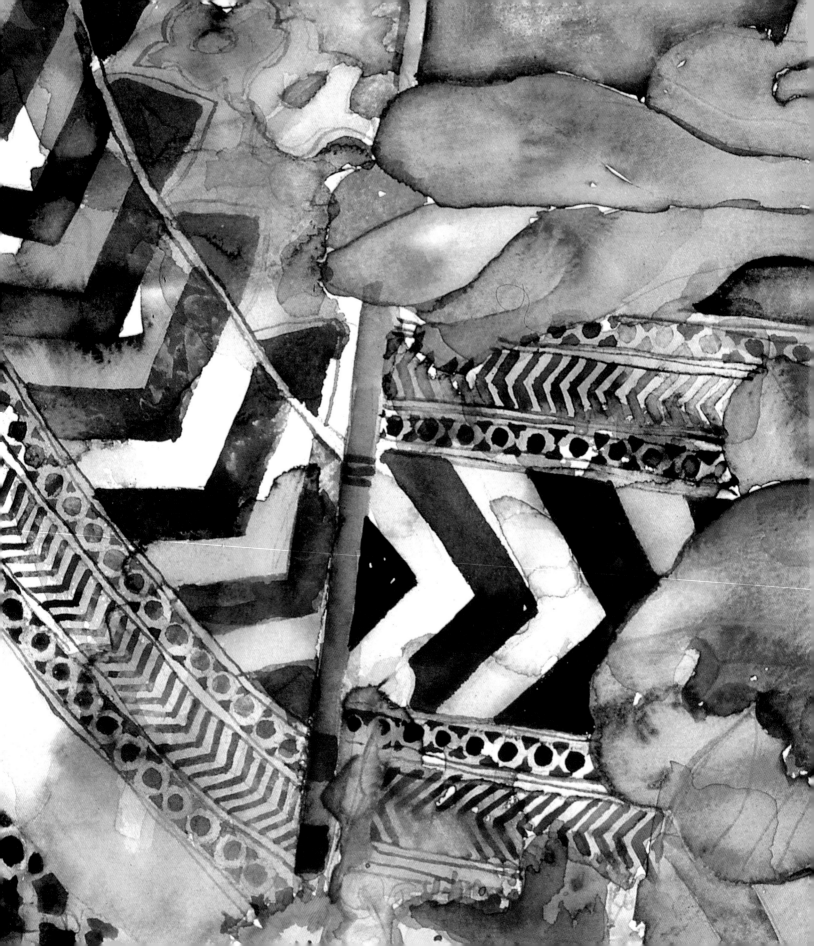

Never use black

Still Life with Black-and-White Cloth

It's the darkest colour, reflects no light and is dismal and dirty – just a few words that describe black. But it can't be all bad, surely. What about its mystery and glamour, the wonderful way it can surround colours and make them become more vibrant and glowing? Think of stained-glass windows, the black lead showing off all that sparkling coloured glass.

Think also of Manet and Matisse, masters of the black. Their oil paintings show how skilful they were at showing black at its best.

Of course if you were in a watercolour class and reached for a tube of Ivory Black you would probably hear a gasp of shock from the tutor and find it confiscated!

Here's one I did earlier

I realized at the very start of my career that I wanted to record every piece of work that came out of my studio – or rather my kitchen, where I did my paintings in the 1980s and some of the 1990s. I am so thankful now that I made that decision. I have given birth to hundreds of paintings – yes, I do see them as my babies – and they have been passed on to their new owners. But I still have my records to remind me of the good, the bad and the really ugly pictures for which I have been responsible.

Still Life with Black-and-White Cloth was painted in 1994. It was then duly photographed for possible future use. The photographs have been taken from my files to use in this chapter as a good example of how I tried to break the watercolour rule of 'never use black'.

'I've been forty years discovering that the queen of all colours is black.'
Auguste Renoir

Lots of black painting going on.

Left: Detail from the finished painting (see page 96).

Looking for inspiration

A starting point for a painting is when I see an object and just know I can form an interesting still life around it. In this case it was a large black-and-white cotton bedspread with various bold patterns across it, perfect for draping across objects and useful for backgrounds and foregrounds when the white walls of the studio are just not interesting enough. It is the decorative boldness of this cloth that I love – I can't resist using patterns such as this to hold all the shapes of various objects together. Best of all, it had a lot of black in it and I wanted to try my hand at using this 'forbidden' pigment.

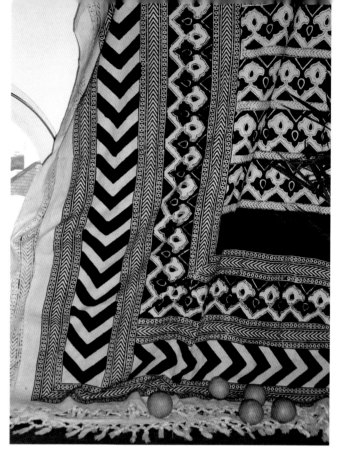

This is the wonderful black-and-white cloth that has appeared in several of my paintings; I find the bold pattern so inspirational.

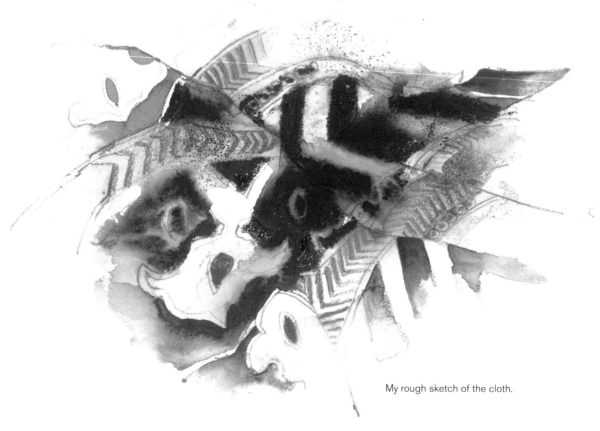

My rough sketch of the cloth.

To go with these bold patterns I chose the large leaves of a fiddle-leaf fig plant that we had at the time. It was far too big to include the whole of it in my still life, but some of the leaves on their own were perfect. Their wonderful fluid shapes made me think of green leather burnished with oil.

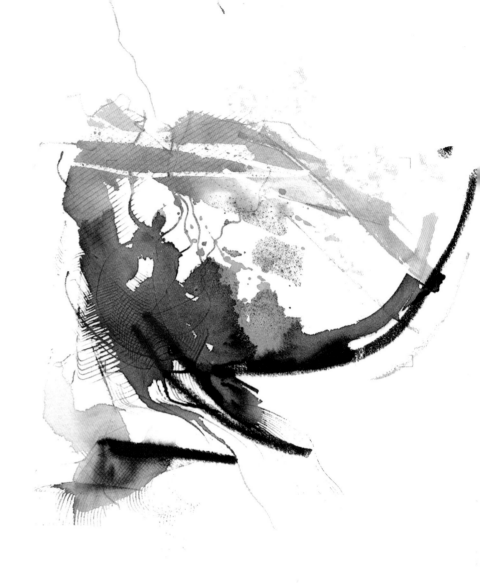

The large, flashy leaves of a bold fiddle-leaf fig plant that dominated the corner of our conservatory.

The rest of the objects were new arrivals to my collection of props. Several of them can be recognized from later paintings, especially the fruit compote dish with a frilled edge and the pencil holder which I have used in *Red Flowers and Figs at Rauffet* (page 19). I think this was the first time I had used a glass cloth in a composition, but it certainly wasn't the last.

There isn't a story going on here in my choice of objects. I am not sentimental about these things or even have them on display in my house. They are chosen for their shape or colour and what sort of relationship I can form between them. This whole still-life set-up was arranged on my kitchen table, the black-and-white cloth draped over a propped-up mirror. We had to dine at one end of the table for a few weeks and no one was allowed to eat the apples or use the pencils. It was tricky not having a studio, but good paintings came along at that time. I quite enjoyed adding a bit of yellow with one hand and stirring the soup with the other.

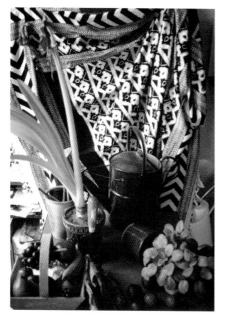

This is an arrangement for another still life composed of garden objects and the black-and-white cloth. Each object is carefully positioned before I start painting.

Going straight in to paint without a preliminary sketch

The 1990s were a good time for my painting; my confidence was so high that I seldom did a preliminary sketch or outline drawing on the watercolour paper. However, the more I have learnt about the pitfalls and problems of watercolour over the years, the more careful I have become. I nearly always do a tiny preliminary sketch before I start painting these days.

And so *Still Life with Black-and-White Cloth* was set up very, very carefully – it probably took me a whole day to do this. If I was going straight in with the paint on the paper I had to be sure the information in front of me was correct and in place. I seem to remember there was a lot of tweaking of the cloths to get the angles right and pushing the orange flower down to touch the pencils. After that nobody dared go near the set-up for fear of altering something.

Even in black there can be coolness or warmth.

Starting with black paint

I remember starting the painting with the black paint for the chevron shapes. Even in black there can be coolness or warmth. I know you can get a rich black by mixing your colours, but as usual I took the easy way out and reached for my tube of Ivory Black, which has richness and warmth.

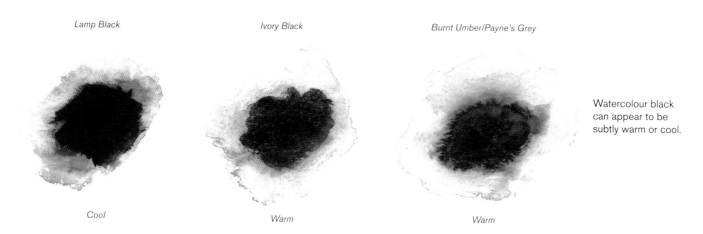

Lamp Black

Ivory Black

Burnt Umber/Payne's Grey

Watercolour black can appear to be subtly warm or cool.

Cool

Warm

Warm

Starting at the top, I painted a curve of shapes down to the leaves then used masking fluid to draw in the pattern at the edge of the cloth. The imaginary purple vertical line you can see in the finished painting (see page 96) was my stop point. I then worked down from the cloth, putting in the edge of the mirror, a black triangular shape on one side and a rectangle joining up with the left side of the paper. Already I had strong boundary lines to work down from. The bottles were partially painted, which led into the pot with flowers and slid easily into the pencil holder.

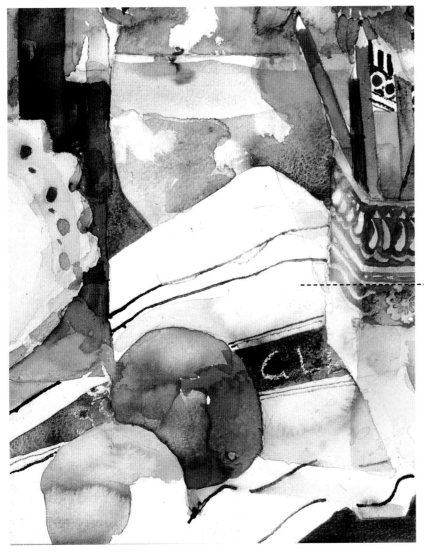

This extract shows the tension between the pot, pencil holder and fruit dish.

The glass cloth was the shape that would tie the whole composition together, touching the pot, the pencil holder and almost, but not quite, the fruit dish, just making enough tension between the objects. The oranges complete this tension, breaking into the very bottom of the picture.

To complete this section was a slow process, just like working on a jigsaw. Each section was considered for its colour and shape, both for the objects and the negative spaces between them. The black may be dominant at the top of the composition but the positioning of the objects and these strong negative shapes give the lower half of the picture a solid base.

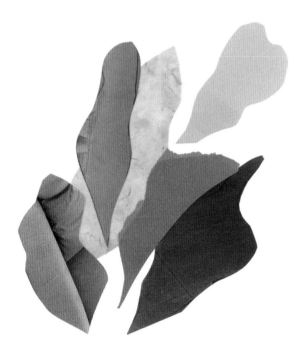

For the leaves, which I knew would be random and not a whole plant, I cut out shapes from some green paper and arranged them down the right side of the picture until I was happy with the composition. Then it was just a matter of drawing around the shapes to make them ready to paint.

Cut-out paper leaves.

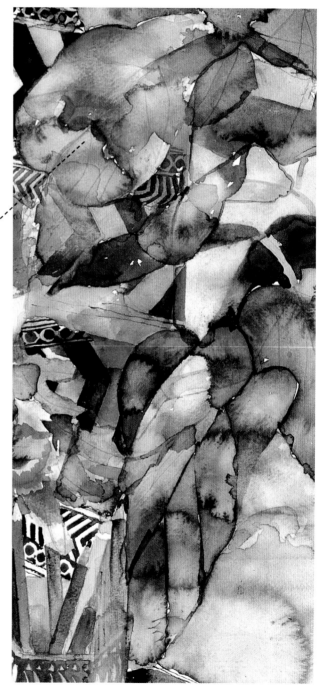

To create this mottled foliage I painted just part of each leaf and let the pigment bloom or backrun with extra water. Before the leaves were completely dry I added more colours to them, allowing the wet paint to pick up the previous washes. This method of taking advantage of watery paint marks and soft colour blends is an example of the unique characteristics of watercolours.

Extract showing the mottled foliage.

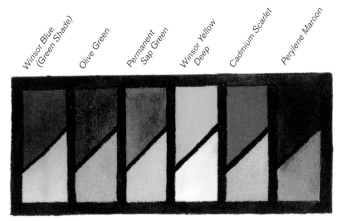

Ivory Black

This chart shows the colours used in this painting, surrounded by Ivory Black. The black accentuates the colours, making them sparkle, as you would see in a stained-glass window.

Once the leaves were painted I could complete the chevron design of the cloth and make decisions about where to put more darks between the flowers and leaves. I had to make sure the black remained stable in the painting, in the right position and in the right proportion. It can easily appear as if a hole has been punched in the paper, so in a still life such as this I had to control the amount of pure black without a hint of another colour. This is why I decided not to introduce it to the lower half of the painting.

The left and right edges of the composition were the last things I painted. I chose a strong orange-yellow for the left side, bringing the negative space to the front of the picture in line with the bottles and fruit. For the right I chose a green-blue, which brought that side curving in to meet up with the pencil holder.

A strong orange-yellow and a green-blue.

Looking at the painting 16 years later

The traditional advice to artists is to confine themselves to two, or, at the most, three planes in a painting. In *Still Life with Black-and-White Cloth* I have tried for several planes, some definite, some vague. I wanted the viewer to get lost in the painting, continually making discoveries as the planes moved from background to foreground, leading them in and out of various corners of the still life. By using black the surrounding colours become brighter and harder, the blackness pushing the lighter tones forward.

Sixteen years ago I became so enamoured of black's ability to make colours shine brightly that I framed quite a few paintings with black mounts. Now that would have upset a watercolour teacher!

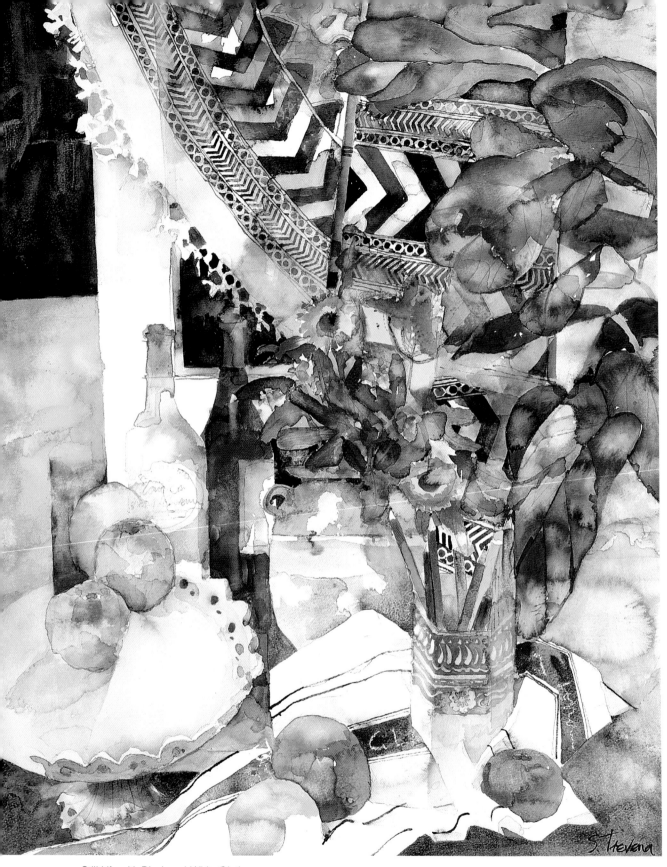

Still Life with Black-and-White Cloth
60 x 48cm (23½ x 18¾in)

Using black in other paintings

I have used the same inspirational cloth in this painting, *Never Use Black* (left), and the title explains how I felt about my colour choices. In this painting the patterns taken from the cloth appear in several places, taking the viewer's eye around the whole composition.

Japanese Screen (below) is mainly composed of dark tones, with the screen, chair and door all painted in black. A sharp balance of light and dark make it an exciting composition.

Never Use Black
55 x 51cm (21¾ x 20in)

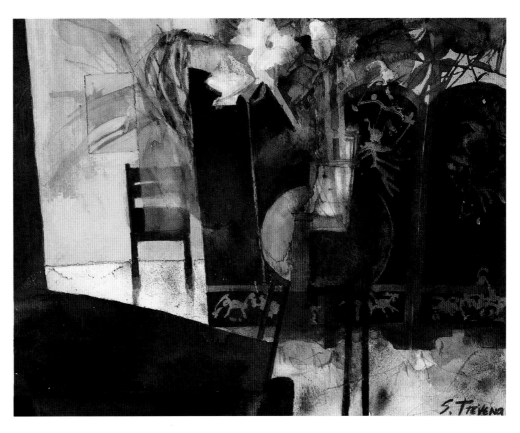

Japanese Screen
27 x 34cm (10½ x 13½in)

Taking desperate measures to save a painting

Green Glass Vase and Pink Chair

After working for a few days on my painting *Green Glass Vase and Pink Chair* I realized that the work was too tight, too carefully painted. And so I made a big effort to break away and use a more intuitive approach – perhaps put it under the tap for a few minutes, cut it up into small paintings or, better still, get out my small scrubbing brush. I could do this because at that point I felt the painting was a lost cause and was making its way to the rubbish bin. After all, what could I lose? Nothing really, except a few hours of playing with paint.

Taking drastic action with the painting.

Creating a painting can go through three critical stages. The first is the excitement of seeing freshly painted marks surrounded by white paper. Can I leave it at that perfect stage? The next is make it or break it time where it may have all gone wrong. Are desperate measures needed yet? The last stage is when the painting suddenly has a life of its own and has taken over completely. You can only go along with it and see what happens.

Left: Detail from the finished painting (see page 107).

Using chairs

Chairs play a large part in my life. For years I have suffered from a back injury and I am always on the lookout for somewhere to perch, but I was well into my painting career before I realized that chairs were popping up all over the place in my compositions. Whether consciously or unconsciously, they had become vital elements in my choice of subject matter. Even my early paintings were of people sitting down; in fact the chairs were already there in my very first painting.

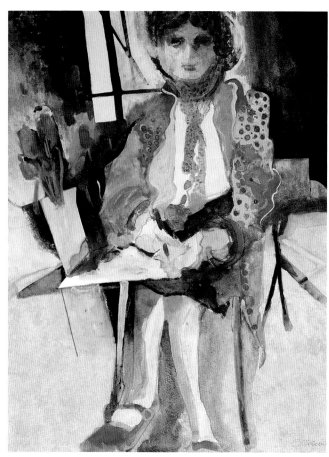

Woman Sketching
47 x 37cm (18½ x 14½in)
One of my very first paintings (1982), and even at that stage I had the model sitting down sketching.

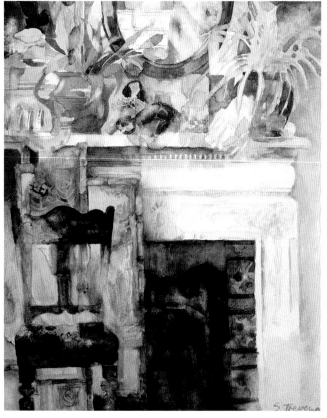

Bedroom Chair
47 x 37cm (18½ x 14½in)
An early painting (1987) of my bedroom, complete with a favourite chair.

Green Glass Vase and Pink Chair is a good example of me using my favourite object. This is quite a personal painting in that it tells the viewer about my leisure time. The squishy, comfortable chair is pushed close to the table, which has an arrangement of cups and bottles with glorious flowers leaning over to encompass the whole composition. You can almost see the mist of their perfume flowing over the scene.

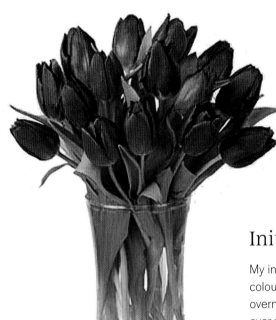

*I can't resist
painting tulips;
I think they are my
favourite flower.*

Initial inspiration

My initial inspiration for this painting was a large bunch of purple tulips – an unusual colour for this flower but perfect for a green vase. I had put them in water and overnight they had behaved just as tulips do, becoming softer shapes and leaning over to one side. I can't resist painting tulips; I think they are my favourite flower. I set them up on a table behind cups and saucers and various bottles to give some height to reach up to the flowers, creating a link between table and tulips. A chair to the right of the composition would be ideal to fill that large open space, but for that information I would have to rely on finding a photograph of a chair with curvy arms, a padded seat and shapely legs from my large selection of reference material.

Green and purple, my
inspirational starting point.

Sketching the ideas

My initial quick sketch shows how I was interested in splitting the composition into two parts, one red, one blue, giving a strong horizontal line across the paper. The chair was drawn from my imagination at this point; straight on, facing the viewer, giving me some much-loved vertical lines.

My first preliminary sketch.

My second rough sketch was more detailed, drawn with graphite pencils and oil pastels. I experimented with the placing of the chair, making it turn to the right to be partially obscured. The horizontal line is still in place but now I have placed a white abstract shape in the centre of the painting. So far I had a fairly tight composition with lines creating rigid areas.

This second sketch has a lot more texturing and scratched marks and I find that the trouble with having such a detailed preliminary plan is that I struggle to reproduce it on a larger scale, especially when it has been sketched with different media. Sometimes I have to discard my initial ideas, put away the sketches and work with the marks that come about when I start to paint.

A more detailed second sketch.

Starting the painting

I began by painting the flowers in a mixture of French Ultramarine and Quinacridone Magenta; I always like to start with my original inspiration. I then moved on to try to achieve the textural dark indigo background, preparing the paper with masking fluid and in some places black underpainting. When this was bone dry I proceeded to paint over it with Indigo and Cobalt Blue, scratching through the paint with twigs and card to make more textural marks.

Choosing my colour combinations with pieces of cut-out paper – deep purple-pinks, lime green and turquoise, a mouth-watering combination.

The perfect chair, photographed outside a local antique shop.

I didn't own a green vase so I chose a plain glass one and added some green watercolour pigment to the water, giving the illusion of green glass.

The chair was my next challenge. I didn't have a sufficiently beautiful chair in my stock of reference material so it looked as if I would be searching through my magazines again for a suitable photograph – but one morning I was in my local bread shop, which was next door to an antique shop, and voila! Sitting on the pavement in front of the window display was this chair, exactly the shape I needed. Thanks to my compact digital camera, which always sits in my bag, I got the pictures I needed to give me the vital information about my perfect chair. It wasn't pink and red as I had envisaged but I could easily change that. I lightly drew in the shape of the chair, not quite trusting myself to plunge straight in with paint, but leaving it a simple outline so that I wouldn't fall into the trap of just filling in the shapes with colour.

Perylene Maroon, Alizarin Crimson and Quinacridone Magenta.

The table was placed on a carpet, which was in fact a bland beige, not my vibrant mixture of Alizarin Crimson, Quinacridone Magenta and Perylene Maroon. I prepared the paper with strong graphite pencil lines defining the various objects on the table set-up in front of me. These lines would be smudged and lightly painted over later in the painting process, but definitely not filled in with colour. These vertical pencil lines lead the eye straight up to the glass vase.

After several days of painting I realized I was at that stage when I could either tear up the painting in despair or hide it in a drawer for a few years.

The doubts set in

Up to now I hadn't decided what to do about the white shape between the flowers and the chair in the preliminary sketch and in looking at it again I felt the abstract white shape was too dominant. Without much forethought I started to paint this area orange, and then I began to doubt my decisions for the whole painting. Maybe I should have left the white shape in place – it could perhaps have been the key to an interesting composition.

Graphite pencil lines define the bottle and vase.

At this point I decided desperate measures were needed. After several days of painting I realized I was at that stage when I could either tear up the painting in despair or hide it in a drawer for a few years.

My frustration at the possibility of ruining a painting that had started as promising made me decide to make major changes and really go to town on pushing the paint around with bristle brushes and water – even a scrubbing brush came into it at one point, but watercolour paper can be quite tough if you use a good-quality one. I use at least a 300gsm (140lb) NOT surface paper and also 638gsm (300lb) for bigger paintings, so the paper can stand up to a good soaking.

After I had softened the edges and smudged the paint, something good gradually began to emerge. I then took out a tube of white gouache, the refuge of watercolourists, and started to paint it over parts of the painting, dry-brush style, to take the sting out of the large areas of reds and orange.

Desperate measures can be taken with various scrubbing-out tools.

The centre of the painting, which has several layers of watercolour, graphite pencil, gouache and oil pastel.

The painting starts to come together

The centre of the painting where I had unwisely added the orange now started to come together. Instead of it ending up a mess I think this is now the most interesting part of the painting, with just a hint of orange and the addition of a mysterious group of purple verticals and graphite pencil drawing over the paint to suggest a chair.

Next I added more red to the chair, deliberately going over the edges of the paint to take away the stiffness and make it shimmer and melt into the carpet. I enlarged the green glass vase, curving it down and ending it in a flat square shape, and painted it pale green, layering the colour over the top of the uneven gouache marks. Using stronger greens at the neck of the vase made the flowers look as if they had been tightly crammed into its neck. Then I redrew the various bottles and cups on the table over the textured white gouache, but only partially suggested their shapes as I didn't want them to be the main thrust in this composition; the chair and the flowers were the stars.

Even if I think that the painting is looking good I know that I can make it look better by putting in extra little touches.

Dry white gouache marks create a hazy look around the flowers.

Tweaking the colour and shapes

When I had reached this late stage in the painting and the composition and choice of colours were working I could then get down to the business of tweaking the shapes, pushing into the paint, adding heavy graphite lines and brushing the dry white gouache marks around the flowers to create a hazy look. Then I added lime green oil pastel to highlight the leaves and flowers and a touch of turquoise to mark the neck of the vase. Doing such things is the most important and exciting part of creating a finished piece – even if I think it's looking good, I know that I can make it look better by putting in extra little touches.

The painting has ended up with less hard edges and the colours are in their right proportion to draw the viewer into the domestic setting. The horizontal line cutting into the composition has gone, doing away with that hint of a perspective view and making the whole picture a more two-dimensional image.

This painting has become one of my favourite pieces and I have striven to capture this looseness in my later work. But, as painters know, just because your last painting is exactly what you were aiming for, it definitely doesn't mean the next one will be equally as good. Artistic creativity fluctuates and you have to accept that. I have certainly experienced this myself over the many years that I have been painting.

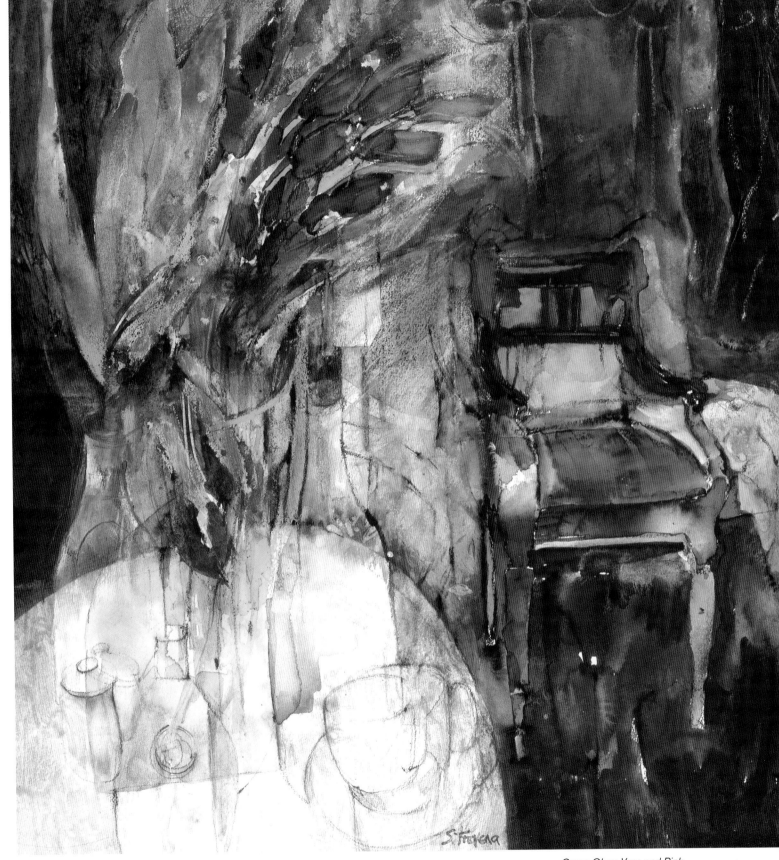

Green Glass Vase and Pink
Chair 51 x 47cm (20 x 18½in)

Revealing white paper

In my pictures, the areas that are unpainted, revealing white paper, are as important in the creative process as the painted ones. Letting the sparkling white of the paper shine through plays an equal part in the colours of my compositions.

'Art must take reality by surprise.'
Françoise Sagan

Leaving white paper shapes and surrounding them with paint can set up some interesting negative spaces.

Left: Detail from *Tea Cloth and Lemons* (see page 113).

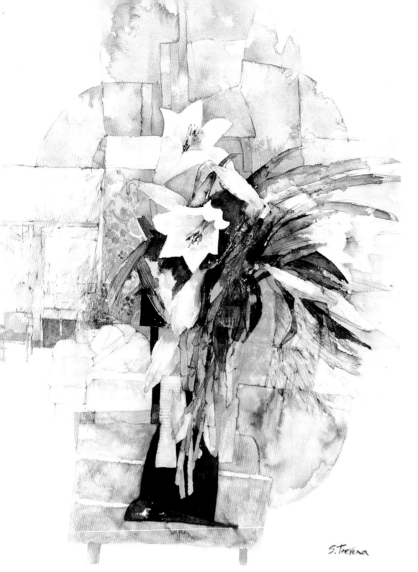

S. Trevena

Anchoring a floating image

Making your subject matter the centrepiece of the composition can leave unresolved surrounding white paper, creating that old problem of what to put in the background.

The black of the vase is the central core of *Dark Vase of Lilies*. It is up close to the viewer and everything that surrounds it fades into the distance. The colours get paler as they spread away from the black until they become the white of the paper.

This is a view of a room with a table top in the foreground. With this type of composition in which the main feature is in the centre of the paper I look for some connection that will bind the painted and unpainted areas. The subject matter here doesn't appear to float away; it is anchored by its delicate contact with all four sides of the paper, the two tiny legs of the table gripping the lower edge of the composition.

Dark Vase of Lilies
74 x 54cm (29¼ x 21¼in)

Strong colours and shapes form the central core for *Rauffet Window* (right). The little wooden zebra is surrounded by the darkest colours to show off its pattern. The colours then start to fade off, the striped cloth melting into the white space and the fruit becoming only just recognizable. The window is partially masked and left as white paper. Once again the painting is anchored down, this time by the repeat round shape on the right-hand side and the smudged dark corner of the window disappearing out of the top of the painting.

Rauffet Window
46 x 39cm (18 x 15½in)

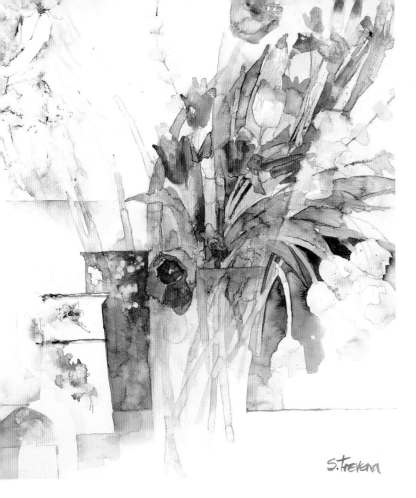

The flowers are the main attraction in *Fresh Cut Flowers 2* (left), springing across the paper with pale colours and pencil lines flowing out to the sides, connecting the painted and unpainted areas.

Fresh Cut Flowers 2
53 x 49cm (21 x 19¼in)

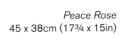

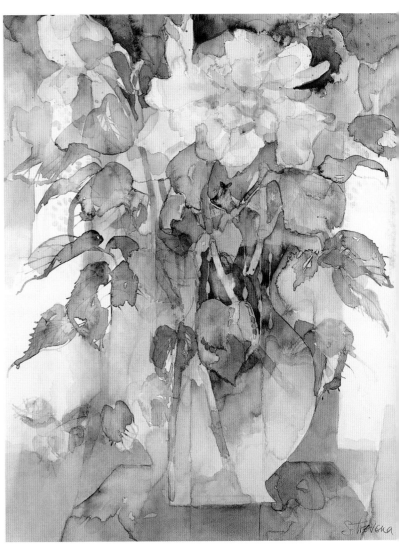

This vase of roses (right) is central to the composition, with white paper defining the left and right sides. The floating leaves give the picture movement. I have left some rather small white areas within the main painting. These now relate to the larger unpainted sections, giving a visual connection.

Peace Rose
45 x 38cm (17¾ x 15in)

Painting from the top, leaving white paper at the bottom

With the composition hanging from the top edge of the paper, the upper third of this painting (right) becomes more prominent. Rich in colour, it moves forward to control the design, stopping it from sprawling out of the picture.

This gave me the opportunity for a lighter technique in the lower section, fading the colours in passages and leaving areas unpainted. There are tiny sparkles of white paper showing all over the composition, linking white with white.

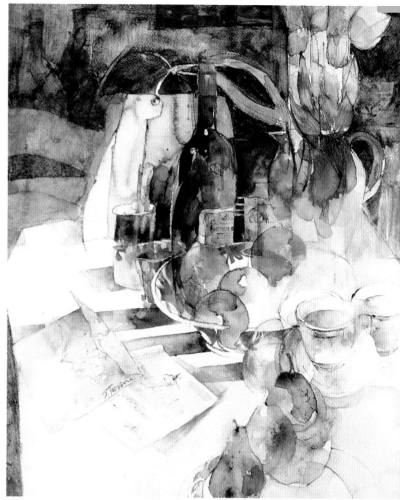

Green Tea and Wine
52 x 44cm (20½ x 17¼in)

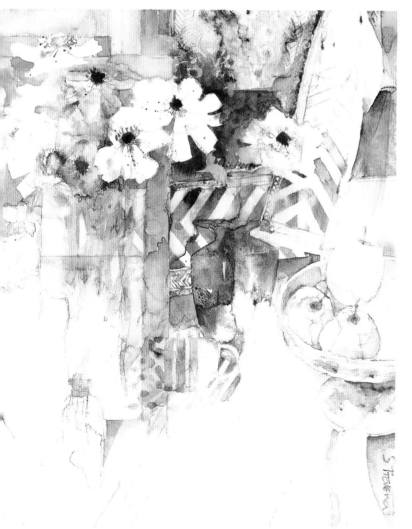

Colours melt and fade away as they drift down this composition (left). Held together by small black and gold areas, this appears to be a symphony in greys. There is a delicacy about the positioning of the objects, while the pure white of the paper is a strong base shape in the composition.

Pink and White Anemones
49 x 38cm (19¼ x 15in)

Completed in 2010, this painting (right) is another example of strong, colourful information hanging from the top of the picture.

Mysterious shapes of pencil lines can barely be seen in the lower half where the white paper has been lightly brushed with colour, which has then been partially washed away.

Still Life with Clay Head
53 x 46cm (21 x 18in)

The tea cloth provides a large part of the white paper design in *Tea Cloth and Lemons* (below) and you are not quite sure where its edges are. Hanging from the top again, the composition relies on the stripes of the cloth and that one lemon on the bottom edge to anchor the whole thing down.

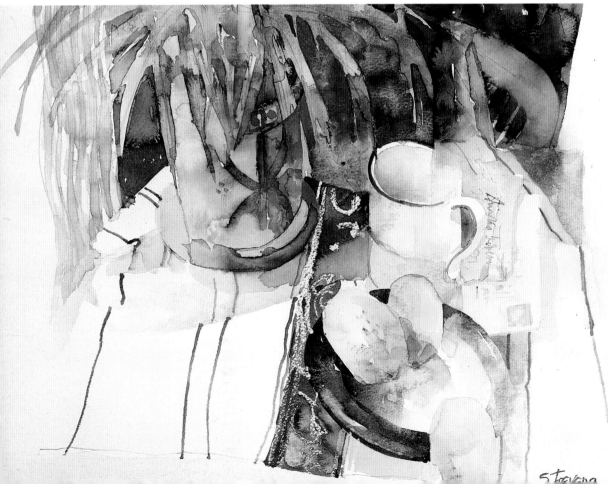

Tea Cloth and Lemons
30 x 40cm
(11¾ x 15¾in)

113

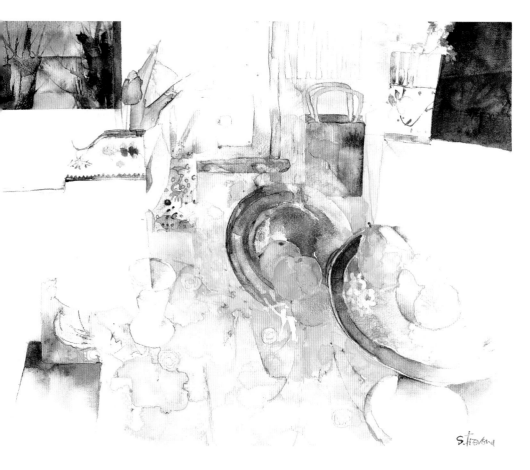

Creating visual tricks with white spaces

Leaving white paper shapes and surrounding them with paint can set up some interesting negative spaces.

In *White Jug, Blue Plate* (left) the white of the background and the objects, or parts of the objects, merge in and out of the composition. The right side of the jug defines a possible edge to the table but its left side flows into the background.

White Jug, Blue Plate
48 x 38cm (18¾ x 15in)

This is my third-ever attempt at watercolour, painted in 1980 (right). The white paper that is unpainted suggests a tree or a possible wall. I knew that I could stop at that point, the painted and unpainted areas forming a complete composition.

Anna's Dream
40 x 35cm (15¾ x 13¾in)

Inside, Looking Out (left) is a view from the window of my home. It is a wonderful sea view with white houses and blue seafront railings.

There is an ambiguity to the shapes surrounding the plant. Is it a black table with legs or is it just a plain white top? Are the arches on the right a part of the terrace or far in the distance towards the seascape?

Inside, Looking Out
42 x 53cm (16½ x 21in)

Teacup and Tea Cloth (right) is an interesting example of how to use white paper to good effect. The white lily cuts its petal shapes into the green, leaving the viewers to form a picture of the whole flower themselves. It's only after staring at the painting for a short while that you become aware of the white vase.

Teacup and Tea Cloth
35 x 40cm (13¾ x 15¾in)

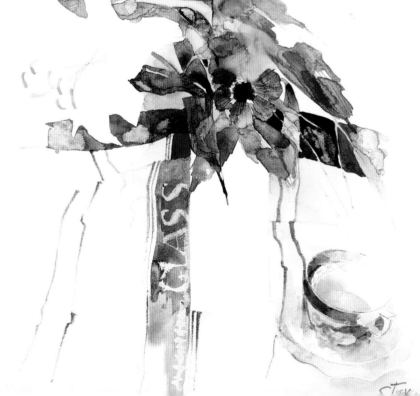

An absence of white paint

I find that there is no white pigment as bright as the white of the paper. Here are a few examples showing how I managed to keep that brightness.

The majority of the flowers in *Brown Jug of Magnolias* (right) have to shine out in this painting. With many colours and patterns floating across the composition they have to look crisp and bold. I decided to leave the white paper to do the work in the petals and concentrated on painting the negative shapes – the dark sections pushing the white petals forward.

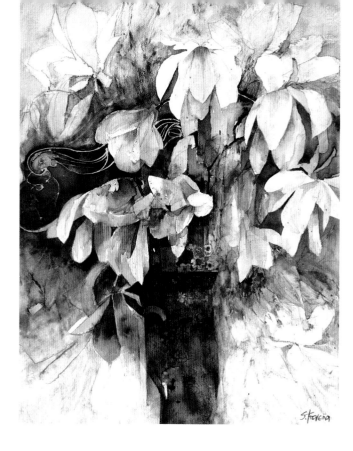

Brown Jug of Magnolias
76 x 57cm (30 x 22½in)

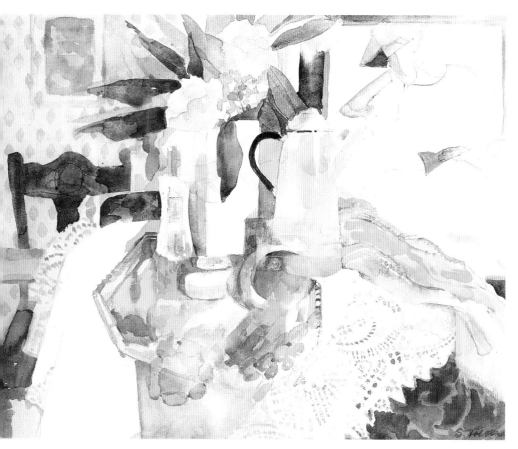

When I was teaching, I found that for some reason my students always wanted to paint the most difficult objects. They would bring to the classes such things as cut glass, silver objects and lace cloths.

This painting does have a glass bottle, a brass tray and lots of lace. The cloth is the white paper shining through and all the lace was completed by just painting the negative shapes – lots and lots of dots put in with a very small brush.

Yellow Jug and Pink Flowers
38 x 48cm (15 x 18¾in)

A vase of white tulips is right in the foreground of this picture (right), and all the tulips, apart from the shaded areas and the stamens, are unpainted paper.

For the lace curtain, the paper was prepared with a light pencil drawing of the pattern and the floral shapes filled in with masking fluid. After that a grey wash was applied and the masking fluid brushed away, leaving this delicate lace curtain.

White Tulips
45 x 38cm (17¾ x 15in)

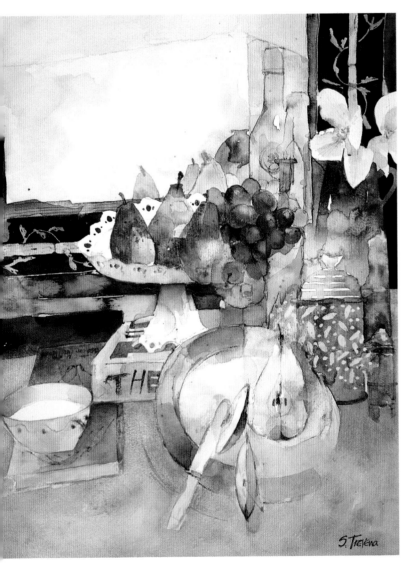

Full of colour, *Still Life with Mirror* (left) is a vibrant still life but I deliberately left the white paper to portray the delicate china fruit dish with its lacy edge. It looks crisp and fine with the black highlighting the edge. The other small pieces of pure white are inside the little sugar bowl and the white flowers to the right of the composition.

Still Life with Mirror
48 x 38cm (18¾ x 15in)

Visual surprises

As a painter of still life I'm always looking for unique material to use in my set-ups. A flower or a bowl of fruit may be considered by some to be commonly used and impossible to interpret into an exciting composition. However, I like to present this sort of material boldly and give the objects originality in their shape, scale or colour, turning that flower or bowl of fruit into a surprising visual treat.

I like to make my viewers work hard to see into the shapes I am presenting, to make some sense of them and sometimes be surprised when they come up against secret and strange objects. I want them to look even closer at that tiny teacup and golden clock and maybe discover a partially hidden object that creates a little joke or a surprise. I could, of course, be including these objects to make sure that my buyers never get bored with their purchases, but sometimes they never are discovered. If you own one of my paintings, have a closer look at it just in case.

'The facility of creating is never given to us by itself. It always goes hand-in-hand with the gift of observation. And the true creator may be recognized by his ability to find about him, in the commonest and humblest things, items worthy of note.'

Igor Stravinsky

I like to make my viewers work hard to see into the shapes I am presenting.

Taking a closer look.

Left: Detail from *Musical Flowers* (see page 120).

Secret objects

Here are a few examples of my paintings that I would like you to look at a little closer to discover their secrets and surprises.

Musical Flowers (right) is a painting of an ordinary brown glass vase holding an assortment of spring flowers. As it is the only object and lacks an interesting background, my task was to turn such a basic still life into a visual treat.

The vase was placed on a shelf without any surrounding objects to help me. So what was I going to use for the background? I had to think of something that would make my viewer take a closer look and get involved in the whole picture, and that couldn't be just a single-colour table or plain background.

The organic shapes of the flowers took over in this painting at a very early stage, springing and dancing across the paper, and that was the impression I had to keep. I imagined peering in between the curvy shapes of the stalks and leaves and getting glimpses of furniture, chairs, of course, being my favourites. There are three chairs curving their arms and legs in and out of this vase of flowers. See if you can find them.

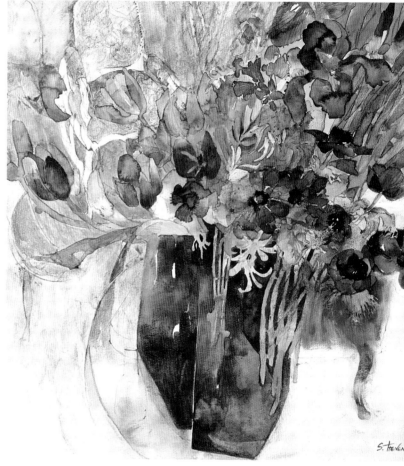

Musical Flowers
52 x 48cm (20½ x 18¾in)

This small painting, *Blue China Pot* (left) shows the delicate blue patterning of a favourite pot that I bought at a car-boot sale. It's cracked and a bit wonky but the pattern is still beautiful.

The painting conceals a tiny metal bird, its body hidden in the pattern of the pot, its legs and tail disappearing into that band of blue and its breast feathers forming a straight line that can also be read as the side of the glass bottle. He is there, but not obviously so.

Blue China Pot
18 x 18cm (7 x 7in)

My favourite Chinese pot again with the so-paintable design, this time with begonias flowing over the edge.

This was painted more than 16 years ago, in a different house with no view to speak of. All the objects are on a strip of rust-red carpet and there's a breeze fluttering the ornate lace curtains.

Making an appearance again beside the blue pot is the wooden rabbit last seen in *Still Life with Chinese Pears*. He appears as a white shape with his pink ears profiled against the window frame. He is pale and understated but still plays a big part in this composition.

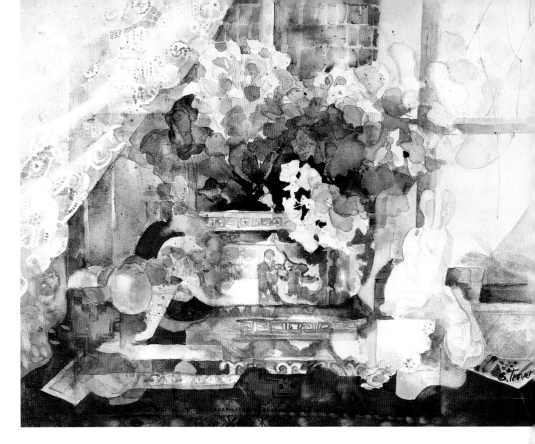

Begonias on a Windowsill
39 x 48cm (15¼ x 18¾in)

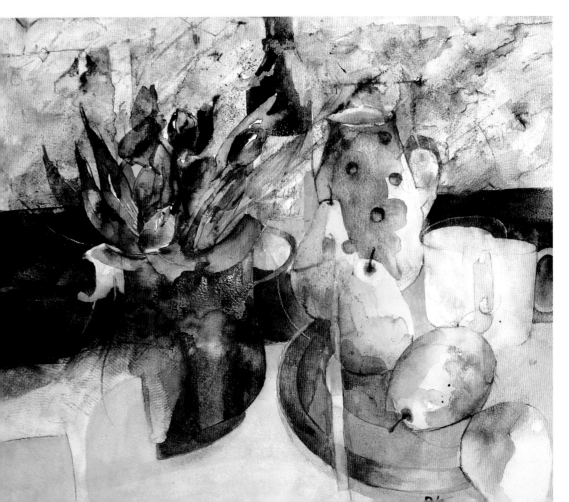

In *Still Life with Copper Jug and Pink Flowers* (left) you can see tulips and pears and a spotty green jug. The jug of flowers looks a bit unbalanced and a little unfinished, but if you look closer you can see the shape of a little animal's head cutting into the copper colour. It is a small metal horse, suggested only by its outline and subtle change of colour.

Still Life with Copper Jug and Pink Flowers
38 x 45cm (15 x 17¾in)

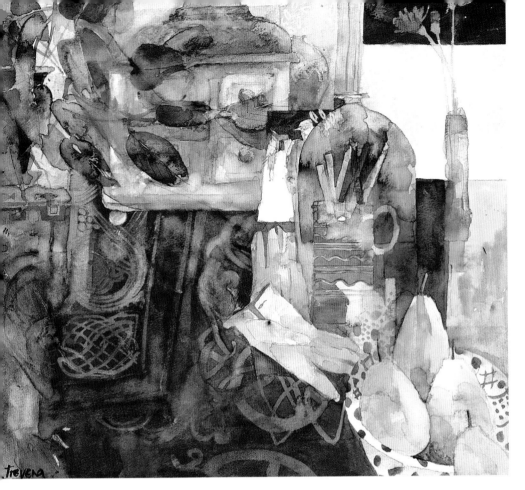

Secret postcards

I like the idea of nestling a small picture inside a bigger picture. I have a collection of postcards that for one reason or another I have found interesting and when I'm gathering together all my chosen objects for a still life I often include one of these cards. I make sure they are partially concealed, inviting my viewer to step closer and take a little time to recognize the image.

Pink Gloves and Pears has a secret picture of David Hockney. You can just see the card tucked behind the big blue pot. There he is wearing his distinctive yellow cap. Why did I use it? Well, the colour combinations and the pink gloves are very Californian and he is my hero.

Pink Gloves & Pears
43 x 38cm (17 x 15in)

In *Cornish Flowers* (right) I was trying to use an old subject in a fresh way. Having bought the flowers, I placed them on a table ready to be put in a vase – but looking at them from the other side of the room I realized that upside down, these paper-wrapped flowers made a neat triangular shape and so upside down they stayed. The Cornish bits are the watering can I bought in St Just and the postcard of a painting by Dod Proctor, a Cornish artist that I admire, who lived in Newlyn for most of her working life.

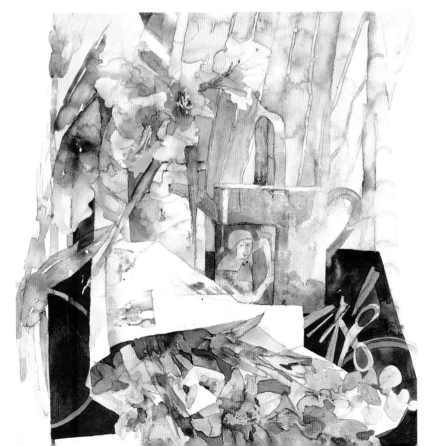

Cornish Flowers
55 x 51cm (21¾ x 20in)

Jane's Postcard (right) is a still-life painting with the usual elements that fuel my imagination, but right in its centre – the focal point, in fact – is a card that is a portrait of a woman with a lot of hair. It is a photograph of a small ceramic figure made by the artist Jane Muir. I do own this *Little Lady*, as she is called, and she has appeared in several of my paintings, perhaps hiding next to a fancy clock or, as the card is here, sliding into some pears. With her big hair and the sharp edges of the card it's a perfect addition to this small still life.

Jane's Postcard
23 x 26cm (9 x 10¼in)

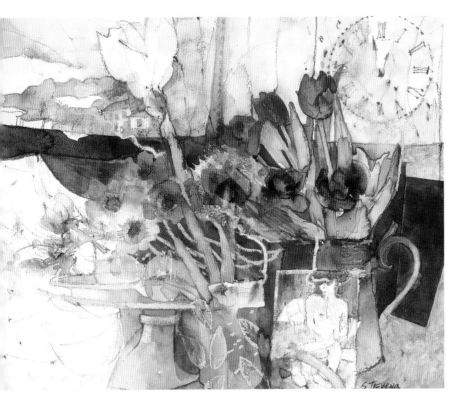

The card that I used in *Bock Street East, St Ives* (left) shows the first painting that I ever completed. I was on holiday, staying in a house in Back Street East in St Ives in Cornwall, and I surprised myself by producing two paintings during that rainy week. Many years later I put this composition together as a memory of that time; a clock for time passing, a view of St Ives harbour and the card of my painting, *Anna*.

Back Street East, St Ives
38 x 47cm (15 x 18½in)

Using surprising objects

I choose objects for their shape and colour and for the possibility they offer of forming an exciting relationship with their neighbour. An early still life, *Cakes and Wine* (right) contains wine, soap, pepper and, yes, cakes – a wonderfully strange mixture, all chosen for their interesting shape or colour. I love the shapes of the cakes, especially the chocolate cupcake nestling against the soap.

This painting was completed at least 15 years ago, but you can still find the cakes in my studio on that same plate. Nothing has rotted away and there's not a trace of mould. Even my cat rejected them; she couldn't get her teeth in them, they were so hard. So much for supermarket preservatives.

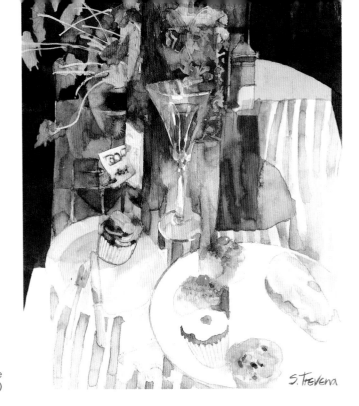

Cakes and Wine
48 x 39cm (18¾ x 15½in)

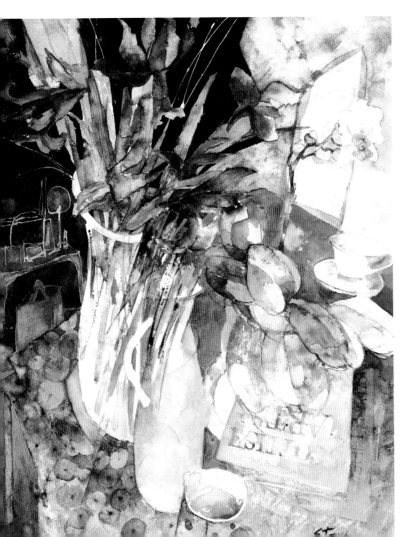

When you look closely at this painting, *Iris and Orchid* (left) you will find quite a few hidden objects. There is a dressing table and half a mirror, a shopping bag and even a strange door or window, but it's the upside-down book with lettering that is my favourite object. Putting secret words somewhere in the composition is another surprise to spring on my viewers and they have to work hard to read them.

This painting says hello to two dear friends: one gave me the beautiful flowers while the Scottish art book is from my friend in Glasgow.

Iris and Orchid
50 x 40cm (19¾ x 15¾in)

This painting (left) is of a sunset in Rauffet, France, with the red and orange sunlight spreading right across the table placed in front of the window. The redness envelops all the objects on the table top, giving me a perfect opportunity to blend the shapes together to form a splash of verticals leading the eye up to the sky. Among these verticals I have hidden a bottle of French rosé wine, which seems to float up to the window, with no base and the leaves of the plant confusing its outline. I was trying to produce an image that would convey that eye-watering blend of colour and shapes that one gets looking at sun-drenched objects. On the bottle of wine you can just see a label that shows a picture of Mont St Victoire, a reminder to me of my French hero Paul Cézanne.

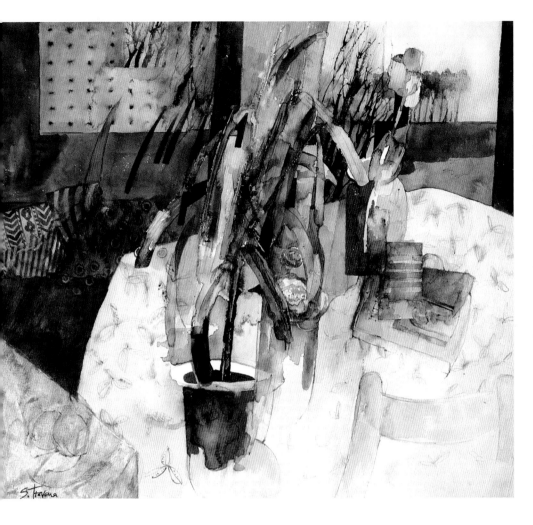

Sunset at Rauffet
52 x 48cm (20½ x 18¾in)

When I buy tea cloths I don't think of washing-up; no, I think 'Perfect for my next still life.' The one in *Still Life with Little Pink Tulips* (right) has appeared in many of my paintings. It contains two of my favourite things: straight lines and, best of all, words – sometimes even backward words, better still. The cloth gives this painting structure, its green stripes blending in well with the coppery pinks of the jug and tulips.

Still Life with Little Pink Tulips
19 x 23cm (7½ x 9in)

Why is there a shoe . . . ?

Of course the answer to the question as to why there is a shoe in many of my paintings is that I have an obsession with collecting shoes – all sorts of shoes, even shoes I know I will never, ever, be able to wear and will only be seen in posing on my settee at home.

However, some of the shoes I have picked for the paintings do have a history and have been worn many times. Those in *Green Shirt and High Heel Shoes* (left) are there to remind me of staggering around New York with my friends many years ago on a big spending spree. You can see in the picture my purchases – a shirt, beads and some perfume – and I've included the paper shopping bag. I think this was the first time I used paper bags in my still-life set-ups.

Green Shirt and High Heel Shoes
48 x 38cm (18⅞ x 15in)

Summer Shoes (right) doesn't tell a story – in fact the summer shoes were chosen just for their wonderful shape. The 'V' of the front, the bow that goes around the ankle and the chisel-shaped toes all feel right for the lower half of this painting. The yellow is a chair and it was with the potted plant in my studio. I added a woman's face at the top. She is admiring my shoes, which were actually made of brown fabric – I used artistic licence to turn them into this fabulous red.

Summer Shoes
53 x 49cm (21 x 19¼in)

Just like the sandals in *Summer Shoes*, these boots (left) started life plain brown, only this time I actually dyed them red. I love the details on the boots, the curvy heels and the laces, which crisscross around the row of little buttons.

It is a painting about an imaginary corner of my bedroom. Fabrics float about, there is a hat, some gloves, the wonderful boots and to complete the composition, a fruit bowl with lemons. I know it is unlikely that there would be lemons on this chair, but the flash of yellow fits well into the complicated design and makes for another of those visual surprises.

Red Boots
53 x 49cm (21 x 19¼in)

The yellow-and-blue striped coat is definitely the star in *Striped Coat and Candy Pink Shoes* (right), but as the stripes flow down the composition they lead into that little piece of stripey fabric and that leads us on to my beautiful candy-pink shoes – peep-toe and slingback, with the straps making great shapes as the shoes lie discarded on the floor.

I choose most of my objects for their shape or colour. I don't have favourite pieces that have a sentimental meaning to me. Even with shoes they have to be an inspirational shape and fit in well with my planned composition, but I must admit the shoes in these four paintings do bring back memories and are like looking at a tiny bit of my history.

Striped Coat and Candy Pink Shoes
48 x 38cm (18¾ x 15in)

Index

*'Painting is not the problem, the
problem is what to do when
you're not painting.'*

Jackson Pollock